A Pocket Business Guide for Artists and Designers

Alison Branagan

A&C Black, London

First published in Great Britain 2011
A&C Black Publishers
36 Soho Square
London W1D 3QY
www.acblack.com

ISBN: 9781408129920

Page design: Howard Whitley
Cover design: Sutchinda Thompson
Project editor: Davida Saunders
Copy editor: Julie Brooke

Illustrations © Tim Bradford 2011
www.timbradford.com

Typeset in FS Me

Details for the tax rates and allowances
included in this publication are subject to
change. Neither the author nor the publishers
can take any responsibility for alterations to
tax rates, or for contact details for the various
businesses and organisations contained herein;
all details were correct at the time of going to
press. If alterations or corrections are found
to be necessary, please contact the publishers
who will endeavor to correct any errors or
omissions on reprinting.

This book is produced using paper that is made
from wood grown in managed, sustainable
forests. It is natural, renewable and recyclable.
The logging and manufacturing processes
conform to the environmental regulations of
the country of origin.

Printed and bound in the UK

In memory of Peter Stanley
Artist and Lecturer
1949–2006

Acknowledgements

Firstly, I would like to thank my commissioning editor, Linda Lambert, for commissioning this book.

Special thanks to consultants Trevor Burgess, Dean Shepherd from Tax by Design Ltd, Jonathan T. R. Silverman of Silverman Sherliker LLP solicitors, David Stubbs, and Albert Wright from Small Business Solutions Ltd.

Further acknowledgement must go to Davida Saunders and Tim Bradford for their huge contribution to this project.

Finally, I am indebted to John Naylor for his advice and consistent support.

Contents

Promotion

31. Will I be discovered?
32. What is wrong with web-based email addresses?
33. What is so important about design format?
34. Should I develop a brand identity?
35. What do I need to promote myself?
36. Is it okay to take my own photographs?
37. How relevant is a CV?
38. Why should I enter competitions?
39. How do I write a media release?
40. What is so important about self-presentation?
41. Why is personal confidence such an issue?
42. What are industry directories?
43. How do I get my work or products into the media?
44. Why should I join a professional body?
45. How do I start networking?
46. Do I need a website?
47. Where should I showcase?
48. Why should I invent publicity stunts?
49. What is sponsorship?
50. How much time and money should I spend on promotion?

Legal

51. Why do I need a working knowledge about legal matters?
52. What is copyright?
53. How do I protect my rights?
54. What is a licence?
55. Why should I apply for design right?
56. What are trademarks?
57. Why should I keep inventions secret?
58. What is the relevance of terms and conditions?
59. What is the point of having a contract?
60. Why should I read a contract?
61. What should I do if I do not agree with a contract?
62. How do I spot a rights grab?
63. What should I do if I have been ripped off?
64. Tell me about DACS
65. What insurance do I require?
66. What is so important about safety?

Foreword

As a student at the Royal College of Art, London, I wanted to become an artist, but by my third year I had gravitated towards industrial design and engineering. I soon discovered that I had a passion for making things that solve problems.

Although I wasn't a businessman, I had to quickly learn the skills necessary to run a company. There were years of uncertainty and financial worries, but going it alone was the right thing to do.

I'd encourage anyone with a good idea to do the same. It will be hard, but just knowing where to start helps: whether it's securing a loan, filing a patent or promoting your idea. This book gives clear, simple advice on 100 questions you need to know the answers to before you set out, and will help you to make a success of your art practice or creative business.

Sir James Dyson

Introduction

> '*Starting a business is one of the most difficult challenges a person can undertake and one of the most rewarding ... if it succeeds.*'
>
> Jay Goltz (1956–), author and creative entrepreneur[1]

This business pocket book is inspired by Jay Goltz, who founded the Artists 'Frame Service, a large picture-framing business in Chicago, USA. Many years ago he wrote *The Street-Smart Entrepreneur*, which comprised 133 useful suggestions about how to set up a business. I was amazed at how much useful guidance it managed to compress into just over 200 pages.

It gave me the notion of creating something similar for applied and visual artists: a pocket guide for a wide range of arts students and creative practitioners, including artists, makers, designers, engineers, architects, inventors, illustrators, image-makers and photographers. Many creative activities require you to obtain recognised business status before you can secure freelance contracts, commissions, workshops and exhibitions. Learning about your industry sector and acquiring enterprise skills is vital in order to earn money legally from selling artwork, products or services.

Some readers may already have purchased *The Essential Guide to Business for Artists & Designers,* which offers a more in-depth introduction to setting up a business as a self-employed individual or with others. This publication will help you find answers to a number of business questions that you may feel embarrassed to ask. It provides useful signposts to relevant websites where further research can be carried out.

I hope that you enjoy reading this book and that it will enable you to make informed decisions about getting started.

Notes for the reader

As this guide is written for a broad readership, you will often find the expressions 'artwork', 'creative products' and 'creative services'. This is to avoid making the text overly complicated with detailed references. Please apply your own definition to these phrases whether you are a painter, printmaker, ceramicist, animator, industrial designer or photographer. The general term 'business' is used to describe any arts practitioner, applied artist, designer or photographer who wants to be self-employed, or to form a partnership, cooperative or company. Many artists and designers may refer to 'a practice' or 'freelancing', which describes the nature of their trade. To sell your artwork, creative products or services legally, you must register with HM Revenue & Customs (HMRC) or Companies House.

[1] Jay Goltz, *The Street-Smart Entrepreneur: 133 Tough Lessons I Learned the Hard Way*, 1st edn (Omaha, Nebraska: Addicus Books, 1998, p.22).

Business

Why should I register as self-employed?

After leaving art college, you may be unsure about what to do next. You may be apprehensive about taking the first steps in establishing yourself as a professional artist or designer.

If you are planning to undertake freelance work – namely where the person asking you to do the work expects you to pay your own Income Tax, National Insurance and usually to have your own insurance cover – then you should register as self-employed (being self-employed is also referred to as being a sole trader).

If you have been asked to submit an invoice to a customer or client, this means that the client presumes you are 'trading' and you are not on the payroll of the organisation or company.

Equally, if you intend to undertake commissions, run workshops or sell your artwork, creative products or services, then you should register as self-employed with HM Revenue & Customs. Registering with HMRC is free in the UK. *Please refer to Q.89.*

You should start thinking about registration, whatever the amount you think you will earn. If you intend to trade, even if you will be making a loss, then you should register. There can be advantages to registration even if, initially, you are making a loss or only trading on an ad hoc basis.
See Q.84, Q.88 and Q.89.

If you have a job and are also working for your own clients or selling products outside your working hours, you should be aware that in most cases this counts as trading and you should register as self-employed. Many artists and designers are employed and self-employed at the same time.
See Q.71 and Q.79.

Increasingly, employment contracts request that you ask or inform your employer about running a business outside your contracted hours. You may discover that the terms of your contract restrict or even prohibit your ability to run a business while employed.

Please note that if you are a foreign national and not from the European Union, then you will need to seek advice from an immigration solicitor before commencing in business. Student and work visas do not grant non-EU citizens the automatic right to trade.

RESOURCES

Business support
www.nfea.com (enterprise agencies)
www.lawsociety.org.uk (lawyers for your business)

National business support services
www.businesslink.gov.uk (England)
http://fs4b.wales.gov.uk (Wales)
www.investni.com; www.nibusinessinfo.co.uk (Northern Ireland)
www.bgateway.com; www.culturalenterpriseoffice.co.uk (Scotland)
www.primeinitiative.co.uk (for those over the age of 50)
www.ibconsulting.org.uk, Institute of Business Consulting
www.hmrc.gov.uk (request or download the registration form CWF1 here)

Books
The Essential Guide to Business for Artists & Designers,
Alison Branagan (London: A&C Black, 2011)
A comprehensive enterprise guide with a detailed list of professional bodies.

Key arts and business organisations
ww.a-n.co.uk
www.artquest.org.uk/money/how-to-start-a-creative-business.htm
www.ecca-london.org/directory/regional-support/

Arts councils
www.artscouncil.org.uk (England)
www.artswales.org.uk (Wales)
www.artscouncil-ni.org (Northern Ireland)
www.creativescotland.com (Scotland)

Crafts councils
www.craftscouncil.org.uk
www.craftni.org (Northern Ireland)
www.ruralcraftsassociation.co.uk
www.designcouncil.org
www.ukfilmcouncil.org.uk
www.londonfashionweek.co.uk
www.britishcouncil.org/arts

Other business organisations
www.fsb.org.uk
www.mas.bis.gov.uk
www.ukti.gov.uk (grants for overseas trade fairs)
www.bis.gov.uk (information, regulations and grants)
www.uk.accaglobal.com
www.icaew.com
www.taxaid.org.uk
www.can-online.org.uk
www.sel.org.uk
www.shapearts.org.uk
www.dada-south.org.uk (see '7 Steps to Self Employment' in the *Resources*
section of this website)

Immigration and visa information
www.homeoffice.gov.uk
www.ukvisas.gov.uk

Is seeking guidance advisable?

Setting up a creative business or as an arts practitioner can be problematic.

For most artists and designers, their business is entrepreneurial or innovative. They have often developed their own range of products or collections, or assembled a body of work in isolation from the wider market, whereas the usual route to setting up in business is to undertake market research to ascertain what demand there is for particular products and services – and only then endeavour to supply them.

Thus visual artists usually embark on business ventures back-to-front. You may be unaware that bringing something new to the market is the hardest way to start trading, and to be successful requires a great deal of business knowledge. This is why gaining advice from others in your field, such as IT/technology consultants, designers, manufacturers, business advisers, mentors, solicitors and accountants can be invaluable.

There are many more fiscal and legal issues to be aware of before starting a business than there were even ten years ago. If you fail to understand these matters you risk being ripped off, losing your creative rights, being fined for not complying with regulations, or causing harm to yourself or others.

Many of the professional bodies, innovation centres and organisations listed in this section offer some degree of support for free or at low cost. However, it is likely you will have to pay for any specialist advice.

RESOURCES

Please refer to the resources in Q.1.

Q3

What should I do if I want to work with others?

Many artists and designers work alone, but sometimes working with others can be advantageous. Often, forming a studio group gives you additional strength, enabling you to progress your career more quickly through collaborations or by forming a cooperative, partnership or company.

However, working with friends or acquaintances can be fraught with difficulties. There are several factors you should consider to avoid problems.

1. When artists or designers jointly create new artworks, creative products or services, even on an informal basis, they may have a co-ownership of rights. That is why it is worth investing in an agreement drawn up by an intellectual property (IP) solicitor. Without having a proper agreement, even when working informally, disputes can arise about the control and exploitation of rights. ⮡*Please refer to Q.52, Q.55, Q.56, Q.57 and Q.59.*

2. Avoid putting any money into a joint venture, even into a joint bank account, before a proper agreement is in place.

3. In any joint initiative, such as a group exhibition, it is important that the project is well managed, with regular meetings and contributors adhering to agreed roles, responsibilities and deadlines.

4. Before setting up a business with others, seek advice from business advisers, accountants and solicitors. Most professionals will offer a free initial consultation before a fee is agreed.

5. To minimise the risk of failure, write a business plan together and set out your agreed objectives.

RESOURCES

⮡*Please refer to Q.59 and the resources in Q.1.*

What is a private limited company?

A private limited company is a business structure that has a separate legal identity from its owners, who are known as shareholders. These can be (but are not always) the company directors, employees, investors or other family members.

Private limited companies may be set up with only one director and one shareholder, who can be the same person – you.

This type of business is usually formed to limit personal financial risk. High earners may also trade in this way to reduce tax liability. Companies must be registered at Companies House, increasing the status and credibility of the business.

If you decide to set up a company as a sole director or with others, it is advisable to have an accountant. A shareholders' agreement, which sets out roles and responsibilities, should be drawn up by a solicitor.

If you set up a limited company it is important to understand that, in contrast to being self-employed, where accounts remain private, some details of the company (including personal details of its shareholders and directors) will be available online for the public to inspect for a small fee.

There are other forms of companies such as public limited companies, companies limited by guarantee and community interest companies (CICs). For more information see the resources below.

RESOURCES

Please also refer to Q.92, Q.93 and the resources in Q.1.

www.companieshouse.gov.uk
www.socialenterprise.org.uk

Q5

Should I set up a company?

There is much to learn about this type of business as companies are costly to set up and are heavily regulated. They are also generally costly to maintain.

Do not rush into setting up a company. Give the simpler option of being self-employed a go first. However, if you are planning a large venture with some degree of financial risk, such as starting a television production company, design agency, shop or gallery, then to limit your personal exposure it may be wiser to set up as a registered limited company.

It is possible to be self-employed and a company director of a separate business at the same time, and to be an employee of another business or organisation.

There are advantages to setting up a company besides those mentioned earlier. One is some limited protection of your business' name. Once you have a company name, this has some protection in the marketplace, although this advantage will be limited unless supported by a registered trademark.

However, you should be careful when choosing a business or company name to ensure that it is not the same or similar to an existing trademark in the same area of goods or services. *Please refer to Q.7, Q.9, Q.34 and Q.56.*

Given the complexity of company law, always seek the advice of a business adviser, accountant and solicitor before proceeding. Failure to comply with the many regulations can result in being fined or, worse still, a criminal record.

RESOURCES

www.companieshouse.gov.uk
www.start.biz (business name search engine plus free information packs on forming a limited company and trademarks)
www.uktrademarkregistration.com (trademark search engine)

Are the arts or commercial worlds for me?

The visual and applied arts sectors and cultural and creative industries take a variety of forms. There are commercial businesses alongside non-commercial organisations, pursuing educational, social or cultural activities.

There is the private sector, which is made up of corporations of all sizes, and the public sector, which includes colleges, community and government bodies. The 'third sector' is used to describe charities, trusts and social enterprises.

You may find yourself freelancing for a large company or running workshops for a local youth centre: it depends on you as a person, your specialism and market demand.

Many arts graduates find the values of large corporate entities unsympathetic or even unethical. This could be why so many arts graduates seek employment in colleges and arts administration.

There is more money to be made from undertaking work in or for large companies, and in other sectors such as design, advertising and architecture. Fees and salaries in the public and community sector are generally lower than in the commercial domain. If you discover that the commercial world is definitely not for you, then there will be other freelance and employment opportunities in charities, colleges and arts organisations. *Please also refer to Q.72, Q.74 and Q.79.*

Money is not everything, but it does help. Whether your ambition is to work in the public sector or run a commercial enterprise is not the issue – what matters is finding the right working environment for you.

RESOURCES

www.prospects.ac.uk
www.yourcreativefuture.org

Should I open a business account?

At the outset you may consider opening a business account, or you may wait until money starts coming in – whether from clients or customers, or cash prizes from winning competitions or grants.

In the UK, there is no legal requirement to have a business account if you are self-employed or in a partnership, but there is if you are setting up a registered company. However, there are many reasons why you should set up a business account just before you register as self-employed.

1. If you are trading as a professional artist or designer, having a business account will convey to clients, customers and suppliers that yours is a bona fide business.

2. If you use your personal account for business purposes, HM Revenue & Customs (HMRC) now has greater powers to examine your personal bank account, going back over several years, if it suspects wrongdoing. HMRC can investigate your business account if it suspects tax evasion or has other concerns.

3. If you have a business account, it will enable you to apply for a business loan.

4. Having a business account separates your business and current accounts, simplifying the task of book-keeping and enabling you to manage your income and tax details more effectively.

5. If you wish to trade under a business name, such as Alison Branagan Studio or Bubble Art, you will require a business account. *Please also refer to Q.5 and Q.56.*

For a bank to accept your application for a business account you must be on the electoral roll and have a good credit rating. Sometimes banks may require evidence that you are trading, such as letterheaded paper, a business card or a recent sample of book-keeping. If you have a poor credit rating or debt issues, some specialised business accounts are available, for example a NatWest or Royal Bank of Scotland Foundation Account.

Usually banks will offer free banking and other services for 12 to 24 months. It is worth shopping around for a bank that suits you. The Federation of Small Businesses offers members free business banking for life with the Co-operative Bank.

RESOURCES

Please also refer to Q.5, Q.9, Q.34, Q.56 and Q.82.

www.fsb.org.uk (membership deal offers free banking with
the Co-operative Bank)
www.barclays.co.uk
www.co-operativebank.co.uk
www.hsbc.co.uk
www.lloydstsb.com
www.metrobankonline.co.uk
www.natwest.com
www.northernbank.co.uk
www.bankofireland.co.uk
www.rbs.co.uk

How expensive is it to set up a studio?

Finding a suitable studio anywhere in the UK can be a problem. There is usually a high demand for professional studio complexes, which in turn means there are waiting lists. To obtain a studio or shared space in a popular complex often requires patience.

Studio rates vary from £50 to more than £300 a week. A deposit will be required and you need to check if there are any extra costs before signing a lease. You might wish to take out public liability insurance and a policy for your studio contents, artworks or products.

Explore less expensive options before hiring a studio or workshop. If money is not coming in, then spending huge sums on a studio space is not very sensible. Equally, having a studio can increase the likelihood of sales from open-studio events and allows you to access other support such as business training.

You may wish to set up your own studio complex or convert part of a commercial premises into a workshop. Many artists and designers have done this, but it will cost thousands of pounds to do so properly. You may need to apply to the local council for planning permission; any alterations will have to comply with fire, health and safety and building regulations.

Many creatives work from home and this is an inexpensive way to get started. There is also much to be said for subsidised business incubation units.

RESOURCES

⟳ *Please also refer to Q.17, Q.18, Q.26 and Q.65.*

http://nfasp.org.uk
www.artquest.org.uk
www.a-n.co.uk
www.rics.org/uk

Q9

Why do I require a maker's mark?

It is vital that your photographs, films, artwork, drawings, sculptures, ceramics, jewellery, textiles, garments and products are signed, marked or labelled in some form in order to identify them as yours.

If you do not sign your work, then you are not enforcing your right to be identified as the 'author'. If work is stolen it may never be returned if the police cannot identify it. The same is true for artists' resale rights, which apply to artists, sculptors, printmakers and to some designer-makers. If work cannot be identified, then it is unlikely you will receive any resale rights.

It is vital that jewellers and silversmiths make sure their pieces are properly hallmarked. A hallmark is a combination of the maker's mark, a metal fineness number and an Assay Office mark. Other optional marks include the traditional fineness symbol and date mark. Unless specifically exempted, all gold, silver and platinum articles offered for sale in the UK must be hallmarked.

Fashion and textile designers should mark their wares using a label. In the fashion industry, it is traditional for designers to seek trademark protection for their name or brand. Trademarking names and brands is also becoming common in all areas of the visual and applied arts. This is partly due to the increased protection offered by a UK or EU trademark, and the increased risk of counterfeiting as a result of the growth in technology and the means to replicate products. *Please also refer to Q.34, Q.56 and Q.70.*

RESOURCES

www.dacs.org.uk
www.artloss.com
www.theassayoffice.co.uk
www.assayofficescotland.com
www.bis.gov.uk/britishhallmarkingcouncil
www.start.biz

What is market research?

You may read this question and think that you don't need to undertake any market research ... but before you turn the page, please keep reading...

In many art and design history books there is little mention of how famous artists and designers actually became successful. It was not by luck or some natural law of inevitability that their clients, customers, or even agents and dealers came calling.

Any activity that is going to help you find out more about your industry and how it works is market research. It includes talking to people at workshops, conferences, exhibitions, fairs and networking events, reading industry periodicals, and keeping in touch with what is happening in your creative field.

Research can take the form of internships and work experience. Equally, it could be desk-based work examining competitors' websites; talking to established artists and designers; asking questions in lectures or talks; making appointments with advisers or finding a mentor; and seeking a range of opinions about how to progress.

Creating databases of press contacts, suppliers, or potential clients and agents also falls into market research, as is joining business clubs or attending enterprise training.

RESOURCES

www.prospects.ac.uk
www.cobwebinfo.com
www.artnet.com
www.designboom.com
www.mrs.org.uk
www.skillset.org

Industry reports
www.ccskills.org.uk (see 'Blueprints' in the publications section)
www.craftscouncil.org.uk (see 'Making It in the 21st Century')
www.artscouncil.org.uk (various reports)
www.designweek.co.uk (salaries and fees)
www.employment-studies.co.uk (see 'Creative Graduates, Creative Futures')
www.creativeeconomy.wordpress.org.uk

Why should I buy a wall planner?

Many computers and mobile phones have pre-installed calendars and project-planning software. Such tools are useful, but there is a problem. It may sound old-fashioned, but I do not believe that you can have an overview of your time unless you can see a year planner on the wall.

Devising a schedule requires the ability to visualise the whole year. Viewing schedules week-by-week or month-by-month on phones or laptops is helpful but is not sufficient for the planning of more ambitious ventures.

Wall planners can be purchased from most high street stationers. Without one it is likely that you will find it difficult to organise tasks and meet deadlines.

To plan commissions, marketing campaigns and exhibitions, properly realistic timetables are essential. You will probably already be aware that projects, especially those involving others, always take more time than first envisaged. It is therefore essential to gain an overview of the year.

It is also important to allow for holidays and time off. When you are working for yourself, it is easy to miss crucial deadlines through tiredness if you don't plan some time for rest.

RESOURCES

Download the Timewerks app at www.apple.com/uk
www.microsoft.com/project (Project Professional 2010 and Project Standard 2010)
http://streamtime.net/uk/
www.ryman.co.uk
www.staples.co.uk
www.whsmith.co.uk

Do I have skills gaps?

Whether setting yourself up as self-employed or applying for a job, you will find there are a number of skills that you need to learn.

The current popularity of emailing, texting and using online social networks means that there is a danger people will lose the ability to communicate orally with ease. But this skill is essential for using the telephone and at interviews, meetings, networking events, fairs and public speaking engagements. Developing confidence in your speaking skills is a key asset in gaining opportunities. Being unresponsive in social or business situations may deter potential contacts from developing a relationship any further.

You will face a host of other challenges in the market, such as gaining additional qualifications, learning how to manage activities and working with others to agreed deadlines. Further knowledge about technological advancements, innovations and ways to use the Internet is also essential.

The ability to market and promote a product launch or exhibition is vital. You will also have to pitch for work, be able to sell, negotiate and present yourself professionally. Learning about tax, bookkeeping, money management and the law pertaining to your field is vital.

You may not be sure what your skills gaps are until you start a business or take up your first job, although it is possible to gain an idea from inititating market research and seeking feedback on your ideas.

RESOURCES

Please also refer to the resources in Q.28 and Q.29.

www.culturalleadership.org.uk
www.missionmodelsmoney.org.uk
www.enterpriseuk.org
www.gew.org.uk

Is reading industry periodicals necessary?

Yes, absolutely.

Printed periodicals published by respected organisations that include features by professional writers are essential for gaining industry knowledge and finding out what is happening in the market.

In fact, it is wise to subscribe, or at least gain access to, a range of journals to inform your thinking and allow you to explore your industry.

But do not leave periodicals unloved and unread in a heap on the floor – make time to read them every month. One of your goals should be to promote your work to a larger audience by securing an editorial feature in one or more of these journals. Work out how you could achieve this, but remember that if you want to promote an exhibition or similar event, you should contact editors, critics or senior writers many months in advance. ⮑ *Please also refer to Q.35, Q.39 and Q.43.*

Many art and design periodicals also have websites that are only accessible to subscribers, or have a special subscription service. These can be useful, but again, be sure to read them regularly.

RESOURCES

www.artquest.org.uk
www.abc.org.uk
www.writersandartists.co.uk

College and university libraries

Who are art buyers?

The term 'art buyer' has different meanings depending on the area of the visual arts in which you work.

If you are an illustrator, animator or photographer, seek out art buyers working for agencies, advertising agencies, or other commercial creative businesses that commission or buy artwork. Lists and databases of businesses that commission commercial work are available from a number of sources. ⊃*Please refer to the list below.*

In other areas of product design and the applied arts, there are 'buyers' who are employed by large stores and other retail outlets to visit trade fairs, or place orders based on an approach by designer-makers or joint enterprises.

Owners of smaller businesses such as gift shops, craft galleries and design boutiques also usually visit trade shows themselves, or deal directly with designer-makers or other creative businesses.

In the fine arts and cultural industries there are art buyers and museum buyers. Art buyers work on behalf of dealerships, while museum buyers acquire exhibits for a museum's collection. Both may purchase precious objects from private collectors or at auction.

RESOURCES

⊃*Please refer to the resources in Q.19, Q.20, Q.21, Q.42, Q.44 and Q.47.*

www.fineart.co.uk
www.theaoi.com (client directories are available from the AOI online shop)
www.aoiimages.com

www.the-aop.org
www.writersandartists.co.uk
www.slad.org.uk
www.vaga.co.uk
www.greetingcardassociation.org.uk
www.ga-uk.org
www.theartbook.com
www.contactacreative.com
www.lebook.com
www.filefx.co.uk
www.adbase.com
www.bikinilists.com
www.workbook.com
www.departmentretailer.co.uk
www.maxfraser.com
www.100percentdesign.co.uk
www.topdrawer.co.uk

What is a residency?

A residency is a residential post for any visual artist, musician or writer. They are advertised on arts e-news networks, in art periodicals, and sometimes by broadsheet newspapers. Residencies can last for up to a year, but many are shorter. They are freelance opportunities rather than employed positions.

Traditionally, residencies are offered by schools, universities, art galleries, hospitals and prisons. More recently, commercial firms have started to engage artists and illustrators in creative in-house projects.

Residencies vary in nature. Some commissioning bodies may expect the artist or designer to work independently and put on an exhibition.

If you apply for a residency, you will usually be offered a fee, a materials budget and access to studio space. Some organisations expect you to interact with the community, to create a public artwork, or to teach a number of workshops. The emphasis of these types of residency is generally on education, improving the environment, regeneration and increasing participation in the arts.

You normally need to have your own public liability insurance before applying for a residency.

RESOURCES

Please also refer to Q.65, Q.69 and the resources in Q.17.

Q16

How do I undertake a commission?

Once you have a commission, whether through making an application or by private agreement, the first thing you must do, before commencing any work, is to sign the contract. If it is a public commission, the organisation or business will usually have its own standard contract drawn up. It is worth knowing that you can request clauses to be amended or revised if you find the terms unfair.

If you are undertaking a private commission, then it is best to have your own commissioning contract. Inexpensive templates are available online from various arts and legal websites, as well as The Artists' Information Company (www.a-n.co.uk). However, it is still advisable to pay an intellectual property solicitor to check the agreement is suitable for your particular purpose.

Before a contract is agreed, set out your own terms and conditions and check that the commissioner is happy with them, you are happy with theirs, and that there is no clash between them. *For more information see Q.58 and Q.59.*

A project is more likely to run smoothly if you fully understand your brief and the contract is clear and comprehensive about your obligations.

Budget carefully and allow more time than you think you need to complete the commission, while keeping within the agreed timescale. You will need to think carefully about insurance, materials, equipment, assistants, sub-contractors and, possibly, a studio in which to complete the work. If you do run into any problems, tell your client when they occur, so you can negotiate for more resources or time.

For larger commissions you will usually receive, or have to negotiate, a proportion of the fee up front, with the remainder being paid in instalments. The arrangements will depend on the type of undertaking. If you need further guidance you should consult your professional body.

Document and date everything: sketches, drafts, CAD files, details of

suppliers, records of expenses, images/photographs of work in progress and the finished work. Compiling evidence of your professional work in a small book, folder, portfolio or on web pages will help you to gain future commissions. ⮌ *Please also refer to Q.35 and Q.36.*

RESOURCES

⮌ *Please also refer to Q.58, Q.59, Q.60, Q.76, Q.77, Q.78 and Q.91.*

www.artquest.org.uk/artlaw

Contact your professional body for more information.

Q17

How do I plan a workshop?

Before applying or proposing to run a workshop, complete a short course in teacher training or workshop planning. Without attending a course, or observing other practitioners teaching a class, you will be unprepared for taking your first workshop.

The next step is to create a draft plan for the session. Include some aims and objectives; the participants may not be interested in these, but the funders will. Then, seek feedback from more experienced teachers, such as friends or former tutors.

A common fault is to be too optimistic about what can be achieved in a single session. For many workshops, whether for adults or children, you will have to prepare some sample objects. If it takes you half an hour or more to make a piece, consider how much longer a novice will take to complete their own version – hours or even days.

Samples are used to show students how the finished article is made and what it will look like. It is a good idea to start a workshop with a demonstration of what the students will be doing. To save time, have other examples or samples at different stages to hand to with which to explain and inspire.

Prepare a handout for the session as this will act as a useful teaching aid. Consider the amount of materials you will require for each participant. Remember to factor in a proper break for refreshments.

When planning short workshops of one to two-and-a-half hours do not make them overly complicated or include too many activities. If people finish early you could invite them to help another student, or provide them with resource books to browse through and paper and pencils so that they can sketch ideas for their next project.

When working as a self-employed facilitator it is advisable to have your own public liability insurance. ⤷ *Please also refer to Q.65 and Q.69.*

RESOURCES

http://jobs.guardian.co.uk

www.artquest.org.uk/opportunities/deadlines

www.a-n.co.uk (opportunities and free public and product liability insurance deal)

www.artscouncil.org.uk (e-news and e-jobs)

www.artsadmin.co.uk (e-digest)

www.isa-gov.org.uk (Independent Safeguarding Authority)

www.crb.homeoffice.gov.uk

www.disclosurescotland.co.uk

www.scotland.gov.uk

www.accessni.gov.uk

Should I try to run a market stall?

There are many kinds of markets, not all of them suitable for artists and designers. Therefore it is vital to research which markets are appropriate for your artwork or creative products.

There are various guides to markets, such as *The London Market Guide*. Information about regional fairs, festivals and boot sales is available from local councils, art news portals and tourist information centres.

You will need to apply to the council for a street trading licence. You may wish to start with a 'casual' licence to see if you can make money from the market before investing more time and resources. Visit the council's website for information about the rules and regulations that apply to specific locations; these may include where you are allowed to park a vehicle and whether you will have to apply for a parking permit as well.

Licences will not be granted to prospective traders without public liability insurance. Some councils run their own schemes, while others recognise the public liability insurance automatically provided by joining the National Market Traders' Federation.

Experimenting with trading on a market stall, or at an art car boot sale, is an excellent way to build a business and acquire first-hand experience of selling and bartering.

RESOURCES

⮑ *Please also refer to Q.65.*

www.nmtf.co.uk
www.artcarbootfair.com
www.apple.com/uk (see the Credit Card Terminal app)
www.fsb.org.uk (PDQ membership deal)

Q19

Should I have my own exhibition?

Exhibiting your artwork and products is an important first step in introducing your work to a wider audience and attracting critical acclaim. There are plenty of online galleries where you can build a presence. However, hosting a show in a venue can be costly.

In the early years, hiring galleries can be very tempting, but if you are unable to invite several hundred people then it could be a waste of money. Start by exhibiting in places where there will be minimum outlay, such as restaurants or country house hotels. This will also give you valuable experience in how to hang a show and run a small marketing campaign.

Another option is to participate in trade fairs with support from a professional body. For example, Craft Central and Hidden Art offer members the opportunity to take part in design fairs.

Forming or joining a collective or studio group is another option. Much more can be achieved when working in a team, as explained in Q.3.

There are numerous ways to exhibit without spending large sums, including taking on an empty shop under a sponsored scheme, a pop-up shop, or showcasing in window displays. ➲ *See Q.1, Q.14, Q.20, Q.39, Q.43 and Q.65.*

Only invest large sums in an exhibition when you have built a substantial client base.

RESOURCES

www.hiddenart.com
www.craftcentral.org.uk
www.verydesignersblock.com
www.peepshow.org.uk
www.craftspace.co.uk

What is the difference between a trade fair and a retail fair?

Visitors to trade fairs are mainly shop owners, buyers and their assistants (who are often referred to as 'runners'). Many artists, designers, professional journalists and bloggers also visit shows such as 100% Design, Pulse, The Spring Fair and Top Drawer. Creative individuals may visit out of interest, for market research, or to find news for their publications or blogs.

Retail fairs are mainly for members of the public wishing to buy directly from small boutiques, designer-makers and artists. Retail/art fairs include The Affordable Art Fair, The Royal Academy Show, Goldsmiths' Fair and Origin.

There are also local and regional selling opportunities such as Christmas fairs and other events where you can apply for a stand or stall. Never underestimate how valuable these events can be – developing a customer base in your home town is essential for generating sales and commissions.

RESOURCES

Please also refer to the resources in Q.1, Q.14, Q.19, Q.21 and Q.42.

www.exhibitions.co.uk
www.excel-london.co.uk (ExCel)
www.businessdesigncentre.co.uk
www.eco.co.uk (Earls Court and Olympia)
www.whatsonwembley.com (Wembley)
www.thenec.co.uk (The National Exhibition Centre)
www.craftscouncil.org.uk (grants for trade shows)

Books
The Essential Guide for Artists & Designers, Alison Branagan (London: A&C Black). Chapter 7 gives a more detailed overview of art and design fairs.

How do I seek representation?

There are a number of ways to gain representation by an agent or dealer.

1. Word of mouth recommendation.

2. Winning a major award.

3. Gaining media exposure.

4. Making a direct approach.

5. By your work being spotted at a degree show, art fair or trade show. Being talent-spotted at degree shows and fairs still happens occasionally, but do not rely on it.

It is important to bear in mind that the demand for representation from illustrators, photographers, applied and visual artists is far greater than can be supplied. Agents and dealers each receive over 1,000 unsolicited approaches a year and it is rare that they will take on people who approach them in this way unless you have something genuinely unique to offer.

It helps if you have been to one of the respected colleges such as the Royal College of Art, the Royal Academy, the Slade, Glasgow School of Art, Goldsmiths (University of London) or one of the colleges of the University of the Arts London. While this may seem unfair, it is true, and research into these agencies and dealerships bears this out. However, do not lose heart. Many creatives who have not attended these colleges have secured representation by a direct approach.

There are several types of representatives: some are limited by territory, for example UK only, US only, Japan only or worldwide; others combine limitation by territory with a particular area of trade, such as editorial, advertising, publishing and prints.

You can approach some sales and licensing agents to work on your behalf. If they are interested, they will travel around the country with your samples,

taking orders from small shops and seeking merchandising deals with manufacturers and gift companies.

Research agencies and dealerships to find the ones that have a synergy with your own style or body of work. All this information can be found on individual companies' websites.

Visiting art and design fairs is another route to finding an agent or dealer. Always make sure you have a small portfolio (A4 or A5 size) in your bag and images stored on your mobile phone or iPod.

RESOURCES

Please refer to the resources in Q.14, Q.20 and Q.42.

www.fineart.co.uk
www.slad.org.uk
www.vaga.co.uk
www.artquest.org.uk (agents)
www.a-n.co.uk
www.writersandartists.co.uk
www.saahub.com
www.theaoi.com
www.greetingcardassociation.org.uk
www.springfair.com
www.autumnfair.com
http://home.the-aop.org/AOP_Agents

Q22

Where do I find clients and customers?

You may have been told that there is a 'right' type of client or customer. This is not the case. If you turn down opportunities because they do not match your expectations you will never get started. Try not to be too narrow in your vision about who will commission or buy your artwork or creative products.

Clients or collectors can be anywhere – and are often not who you expect them to be. It is vital to be alert when reading newspapers, lifestyle magazines or industry periodicals. If you have had a number of sales or commissions do these customers have anything in common? If several are doctors, for example, it may be worth getting an editorial feature or placing an advertisement in *The Lancet*, or exhibiting at a medical conference.

If you promote your early exhibitions successfully, then you will 'recruit' your first customers and collectors. There are also a number of online showcasing websites where creatives can promote or sell their work. Developing networks in your local community can also be a step forward. Ask your friends and family if they know of any potential clients. Direct approaches and marketing to potential buyers are other worthwhile options.

In the early years of your business you might have to experiment with different approaches in order to attract interest to find out what works best for you.

RESOURCES

Please also refer to Q.14, Q.20, Q.21, Q.23, Q.24, Q.42 and Q.47.

Do I understand the client?

Unless they have received some guidance about who to approach, or what type of opportunities they need compete for, few arts graduates will be able to identify their customers, clients or collectors.

If you do not have any relatives or friends in a relevant industry who can help, you will have to carry out market research to establish who is likely to buy your artwork or creative products, where they are, and why they will buy from you. For this you need to develop an enquiring mind. Learn to ask questions to enable you to find out about the people who first purchased your goods or services. By asking a well-timed question you might be able to discover more about why people are motivated to buy; for example, are they buying for themselves or for others?

Being successful in business is completely different from art and design studies. It may require a change of mind-set about your market or industry. You may, for instance, be trying to sell artwork or creative products to individuals, when the real market is in licensing rights or pitching samples to a large store and securing a bulk order.

RESOURCES

Please also refer to Q.22, Q.24 and the resources in Q.1 and Q.10.

www.cim.co.uk
www.a-m-a.co.uk

Q24

How do I sell my artwork, creative products or services?

Selling goods or services, or tyring to attract commissions, makes some artists and designers feel uneasy or afraid, but it is vital to overcome this.

It is important to understand the 'sales process' – how to cultivate interest or enthusiasm in your work and persuade people to buy or commission.

Hopefully your work will be so appealing that it will sell itself. However, even if you have captured the attention of your audience, they will still expect you to talk about the piece, your portfolio or service. There are a number of ways to present the same information, depending on the customer. For example, it is essential to work out what you are going to say when talking to a fellow industry professional and how to adapt it when dealing with the public.

If you are exhibiting at a fair and your creative products fail to capture the attention of the passing visitors, then you need to start to engage with the public. A smile and a simple 'Hello' are a good start. Try to ask open questions to encourage people to talk about themselves and make sure you appear interested in what they have to say. They may like your artwork or creative products but not the price, but without engaging them in conversation it is unlikely that any sale will be made.

If you are a shy person you may need to employ a more extrovert person who can sell for you.

RESOURCES

Please also refer to Q.22, Q.23, Q.47 and the Further Reading section.

Where do I find a manufacturer?

A number of organisations and websites to assist your research are listed opposite.

Before approaching a manufacturer, visit an intellectual property (IP) solicitor who understands your industry to discuss issues such as patent and design rights. If you plan to venture into the commercial world, then some form of registered protection on your invention, design or product is essential.

You may require a Non-Disclosure Agreement (NDA) to be drawn up. This is a contract that is signed by all parties before any commercially sensitive information such as prototypes, CAD files, recipes, drawings, designs or products is revealed.

Failure to have an NDA signed may be fatal to your ability to protect your rights thereafter. *Please also refer to Q.26 and Q.52.*

The solicitor should be willing to attend important meetings that involve negotiating licences or other rights with you. They may charge for this support, but their experience in dealing with contractual matters will more than compensate for any outlay.

Bear in mind that the manufacturing process may change the appearance or nature of your product in some way. For example, alterations may have to be made to enable it to be mass-produced or to minimise costs.

When embarking on any form of manufacture there are a number of legal matters to be aware of. Your product has to comply with British Standards. It may also require a CE mark. *See Q.67, Q.68 and Q.70.* Items must also comply with other mandatory environmental, labelling and packaging regulations.

RESOURCES

www.mta.org.uk
www.mas.bis.gov.uk
www.thedesigntrust.co.uk
www.bis.gov.uk
www.lawsociety.org.uk
www.ipo.gov.uk
http://oami.europa.eu
www.cipa.org.uk
www.alibaba.com
www.mikesmithstudio.com
www.bsigroup.com
www.businessstandards.com
www.cen.eu

Q26

Should I trust people?

The vast majority of successful businesses and professional agents or dealers are trustworthy.

However, there is always the possibility that you may be ripped off, especially when starting out, which is not unique to the visual arts. People who run businesses in any sector encounter problems such as non-payment of invoices, theft, counterfeiting, cancellation of orders, and so forth.

To avoid being taken advantage of, trade with reputable organisations and ensure that you have written terms and conditions and/or contracts in place. It is essential to understand the law and how it applies to your industry. Another sensible precaution is to invest in your own public, product or professional indemnity insurance.

It is also important to present yourself as a legitimate business, with a professional email address, website and stationery. If you do not appear to be very clued-up, and trade from a free email address, for example, then it is possible people will 'try it on', offering the lowest fee on the poorest terms.

There are ways to limit personal and financial liability such as agreeing terms and issuing a pro forma invoice before starting any project. ⤷*See Q.58 and Q.90.*

If you have your doubts about a business opportunity, or find yourself in difficulties, then ask established artists and designers, professional bodies or other advisers for help.

RESOURCES

⤷*Please refer to the listings in Q.1, Q.17, Q.18, Q.25, Q.53, Q.58, Q.65, Q.67, Q.68, Q.69 and Q.70.*

Why do I need to focus?

Time is a valuable resource and must not be wasted.

Setting up a business requires hard work and perseverance. Artists and designers often exclaim that they just want to 'sell their work' and not enter into the complexities of running a business. Unfortunately, selling your work and gaining commissions or freelance contracts requires you to be your own manager, marketer, public relations consultant and banker. It also takes a great deal of time to develop a list of clients, customers or collectors who will buy, hire or commission your work.

Many external factors can interfere with building a business. It is understandable that family commitments, further study or problems with relationships will demand your attention. Concentration can also be easily broken by too much texting and online social networking, or watching junk TV. Try not to be distracted from your projects by such activities.

Creative people tend to be overly optimistic about what they can achieve in a day, week, month, year or lifetime. You may have many ideas about what you would like to do, but you must be realistic as it will be impossible to realise them all.

To track your progress, set a few targets you would like to reach, such as having an exhibition, setting up a website, securing a large order, gaining an agent, etc. Put these on your year planner and try to achieve them within the time you have set yourself.

RESOURCES

↪ *Please also refer to Q.30.*

Q28

Do I require further study?

Just because you have graduated does not mean you have stopped learning.

Teacher training is a popular option for many arts graduates. The Postgraduate Certificate of Education (PGCE) is an intensive one-year course that enables graduates to teach in schools, while shorter courses are available for those who wish to teach adults. There are a number of different adult teaching qualifications and you should check which ones are recognised by the college you wish to teach at.

Postgraduate studies will allow you to undertake further research, or to explore your own practice further. To do this, you should apply for a place on a postgraduate certificate, diploma or MA programme. Funding a postgraduate study can be hard work, but most artists and designers agree that it is worthwhile.

You may need to learn more about software programs or practical skills related to your discipline. Courses in starting and running a business, presentation and promotion may also be relevant.

Many prominent artists and designers have received help from business support schemes. Remember that few established creatives have made a leap from obscurity to overnight success.

RESOURCES

⟳ *Please refer to the resources in Q.1 and Q.12.*

www.ucu.org.uk
www.tda.gov.uk
www.cityandguilds.com
www.edexcel.com
www.direct.gov.uk

Innovation – why is it important?

Most art and design foundation-year and degree programmes promote innovation and encourage students to push boundaries, which is vital if you intend to create original work and specialised services.

In the last decade there has been a digital revolution, which continues apace. Technology has made tasks that once required a great deal of skill relatively easy and inexpensive to complete. Even the skills being taught at colleges today, and in the recent past, may be superseded in the near future.

If you fail to keep up to date by attending workshops and conferences, or by reading articles or periodicals, you may find yourself in difficulties.

Trend forecasting – predicting the future – is another form of innovation. If you are a commercial artist, printer, sculptor, illustrator or designer working in interiors, furniture, textiles, soft furnishings or any other product, it could be vital to understand the key themes, colour palettes, patterns and textures that retailers are planning for the next 36 months.

Finally, remember that every summer there will be large numbers of new arts graduates launching themselves on to the market, just as you did. Maintaining your knowledge base will ensure you stay a step ahead of any fresh competition.

RESOURCES

⟳ Please also refer to Q.57.

www.newscientist.com
www.sciencemuseum.org.uk
www.innovation.rca.ac.uk
www.hhc.rca.ac.uk
www.london-innovation.org
www.nesta.org.uk
www.apple.com
www.adobe.com
www.wacom.com
www.artcam.com
www.dyson.co.uk
www.random-international.com
www.globalcolor.co.uk
www.thefuturelaboratory.com
www.style.com
www.modeinfo.com
www.thetrendboutique.co.uk
www.creativereview.co.uk
www.designweek.co.uk

Why is time management such an issue?

As discussed in Q.27, to run a business you must be proficient in a number of skills. If you are self-employed, you will have 'invisible' work in addition to making or selling your artwork and creative products. You may find that up to 40 per cent of your time is spent on other management tasks that, without assistants, only you can do.

Businesses do not run themselves and without ongoing maintenance they will simply grind to a halt. Emails can easily absorb several hours of your time every week. Then there are general administrative tasks such as book-keeping, ordering supplies, applying for commissions and exploring other marketing possibilities.

It is also important that you check your work. Everyone makes mistakes from time to time and it is well worth putting time aside to double-check any instructions, proofs or emails for errors. Businesses run more smoothly when time is made to check that things have been done properly.

I have met many creatives who have ruined big opportunities by failing to check small but vital details, such as getting the right date and day on invitations before distributing them; forgetting sets of keys for storage units or vehicles; being unaware of strikes; or getting measurements wrong.

There is never as much time as we would like, so to maintain progress you should set realistic goals and avoid taking on too many responsibilities at one time.

RESOURCES

➲ *Please refer to the Further Reading section at the end of the book.*

Promotion

Will I be discovered?

If you are spotted by agents, buyers or dealers at your degree show then this is your first lucky break. However, it is unlikely that an art fairy godmother will magically appear in a puff of sparkly stardust with no prior invitation.

When you are planning any showcase it is a good idea to target potential employers, patrons and collectors as well as agents, buyers, critics, stylists and journalists. Optimistically sending out last-minute emails is not enough. Established industry figures usually have their diaries booked 12 to 36 months in advance. If you really want a prospective client to come to your show, then invite them at least 12 months in advance, and follow up nearer the time with an invitation and a neatly handwritten note.

Try not to be too disappointed if your main guests do not turn up on the night. Always telephone them the following day to see if they would like to come to your show on another day. If they cannot make it, ask if you can visit them to show your portfolio or samples.

The trick to being discovered is to make friends and develop professional relationships in your industry. Networking, obtaining features in relevant magazines, winning awards and imaginative self-promotion will eventually attract the attention of those you seek to impress.

RESOURCES

Please refer to the resources in Q.14, Q.20, Q.21, Q.42, Q.43 and Q.48.

Q32

What is wrong with web-based email addresses?

Using a web-based email service such as Hotmail or Yahoo is perfectly fine for social purposes. However, using transient email addresses for business, or when looking for a job, will not impress the recipient. It is likely that potential employers and clients, who receive vast amounts of email, will not even open emails with amateur credentials.

Internet Service Providers (ISPs), such as Virgin and AOL, offer email addresses that can be used with Microsoft Windows email software. If you have an Apple Mac computer invest in a Mac email address.

If you intend to set up a business, then you should rent a domain name from a domain name/hosting company. These companies usually provide access to an online control panel that can be used to create email addresses and automatically **forward** emails sent to your business address to your ISP account. For example, emails sent to my business email, alison@ alisonbranagan.com, go straight to my ISP email, alison.branagan@virgin. net. You will be able to send and receive emails from your ISP's webmail service, using your business address, from any computer with internet access.

If this description is too technical then you might want to consider paying a web designer a small fee to set up a basic forwarding service for you.

RESOURCES

www.thename.co.uk
http://3dpixel.net
www.ispreview.co.uk
http://top10.com/broadband

Q33

What is so important about design format?

It is important that, as a professional artist or designer, you have a personal design format. This will give your curriculum vitae, stationery, website, presentation and promotional materials a consistent style.

Many artists and other creative people do not have the technical skills to apply a sense of design to their own materials. In business, unless you have a natural flair for design, it is wise to hire a graphic or interface designer to format all your publicity and presentation materials in a style that reflects your personality, business values, character or identity.

In the visual arts and creative industries, most decision-makers will be intuitively drawn to well-designed materials. Paying for your curriculum vitae to be professionally designed will make it stand out.

If you do not have an aptitude for graphic design, then do not try to do it yourself. It is far better to employ an experienced designer across all mediums than trying to do it all yourself or using several people to do it.

For some, a design format will develop into the branding of their own name, business or product name. This branding should in turn be protected by registering names, colours, shapes, logos or images as trademarks at the Intellectual Property Office (IPO).

RESOURCES

www.creativereview.co.uk ('New Faces' column)
www.designweek.co.uk
www.fontsmith.com
www.typography.com
www.fontspace.com

Should I develop a brand identity?

Successful artists and designers create a striking visual identity by inventing memorable motifs, logos, characters or signatures (including tags), or by adapting their own names. Many creatives have slightly changed their own names to make them more interesting or easier to remember, such as Vivienne Isabel Swire (Vivienne Westwood), Jack Hoggan (Jack Vettriano) and Banksy.

Research your industry sector thoroughly before deciding on a business or product name, logo, motif or character. A brand should reflect the ethos and values of the business and be unique and distinct from those used by other companies. The more memorable and appealing your visual identity, the more likely it is that you or your business name will stand out.

Once you have chosen a business or product name, check that the name or logo is not already registered. You may be able to protect your brand by trademark registration e.g. Vivienne Westwood ®, Banksy ®. Both before and after registration, business names can be registered as companies, e.g. Jack Vettriano Ltd.

If you do not legally protect your brand, you may lose the right to exploit it. *Please also refer to Q.5, Q.9 and Q.56.* If in doubt about how to develop and protect your brand, speak to an intellectual property solicitor.

RESOURCES

Please also refer to the resources in Q.33.

www.ipo.gov.uk
www.start.biz
www.uktrademarkregistration.com
www.companieshouse.gov.uk
www.logolounge.com
www.aquent.co.uk

What do I need to promote myself?

First, make a list of the types of promotional materials you need for the first 18 months of your business. Think carefully about how, when and where they will be used. Unless there is a major opportunity on the horizon, take some time to develop such materials. These might include a personal profile or biography, media releases, stationery, brochures, business cards and postcards, websites, web presences, podcasts, showreels (DVD/CD/online streaming), blogs, marketing copy, artistic or design statements.

After you have drafted this list, and before spending any money, undertake further research into how best to market yourself.

Hard-copy materials in the form of business cards and postcards are your most important frontline marketing tools. Leaflets, flyers and brochures might also be useful, depending on who you are targeting.

Professional photographs of yourself, your artwork and your creative products are also essential. Editors often require photographs of artwork or creative products situated in a gallery or studio, or in a domestic setting for interiors or lifestyle features. It is better to have five good-quality photographs that can be used to generate media exposure than have dozens of mediocre ones.

Photographs or digital files can be used for a number of purposes, such as print, web, email, e-signature, PDF portfolio and Keynote or PowerPoint presentations. Images of artwork or creative products may need to be cut out for magazine features. If you are a film-maker or animator, then it would be useful to produce a number of high-quality stills.

Developing an online presence on social networking websites, design portals, art forums, online galleries, shops or portfolio sites is essential. Showcasing short film clips online is becoming increasingly popular. Having your own website is still important, though. If short on funds, invest in a well-designed holding page or a three- to five-page website, rather than using a cheap template option, as a glance at your website will tell clients and customers that it is cheaply designed. Showcasing yourself on poorly designed interfaces will not help you to connect with the right market or audience.

It can take around 18 months to gather all the materials to promote yourself or your creative business in the media, and to develop an online presence.

RESOURCES

Please also refer to the resources in Q.38, Q.43, Q.45, Q.47, Q.48 and Q.50.

www.artrabbit.com
www.artscouncil.org.uk
www.creativeboom.co.uk
www.designboom.com
www.flickr.com
www.twitter.com
www.facebook.com
www.youtube.com
www.printing.com
www.urbanprinting.co.uk
www.abacusprinters.co.uk
http://uk.moo.com
www.bladerubberstamps.co.uk
www.fabricprint.co.uk
www.redbubble.com
www.photobox.co.uk
www.blurb.com
www.londongraphics.co.uk
www.silverprint.co.uk

Is it okay to take my own photographs?

It is unwise to use amateur photographs or poor-quality images online or in printed materials. If you study established artists' and designers' websites, or other online presences, they always use a selection of high-quality images.

If you are planning to charge substantial sums of money for high-quality artefacts such as furniture, jewellery, sculpture, models or textiles, or if your artwork or creative products are particularly difficult to photograph, then it is essential to use a professional photographer.

If attempting to gain exposure in any form of printed media, such as catalogues, brochures, industry periodicals or glossy magazines, it is vital to submit professional photographs. Three to five high-quality pictures will increase the likelihood of them being selected for editorial features or placed on exhibition posters.

Most contemporary illustrators and image-makers create their work digitally. It is advisable to save files in different formats and have high resolution versions for print and lower resolution ones for use on illustration, animation, moving image and design portals.

If funds are limited, then avoid rushing into having professional photographs taken until you have selected which artwork and creative products urgently need to go online, or be sent to the media. Barter with photographers if you are unable to afford their fees. You could offer to swap a piece of artwork or a product for their time, or undertake a commission for them in return for their services. (Always remember to check such exchanges for tax implications with your accounts.)

When commissioning photographers, always request an outright 'buyout' of copyright from them to you as part of the agreed fee. This means you will be able to use the photographs for any purposes you wish without incurring further expense. However, you are still obliged to credit the photographer when images are reproduced in magazines or online, even if you own the copyright, unless the photographer specifically states that he or she waives their moral rights in the terms and conditions or commissioning agreement.

If you take your own photographs then you automatically own the copyright in those images, but you should similarly claim moral rights in the image.

RESOURCES

Please also refer to Q.39, Q.43 and Q.52.

www.artquest.org.uk/artlaw
www.artquest.org.uk (portfolios/photographers)
www.the-aop.org
www.own-it.org
www.bipp.com
www.rps.com

How relevant is a CV?

When you graduate it is likely you will require three different types of curriculum vitae (CV). The first is a standard CV for non-specific job-hunting, which you can tailor to suit the purpose. The second is for art or design employment opportunities. This should be a stylish document of no more than two pages, to be used for positions related to your degree or skills. It may include colour thumbnail images of your recent projects. The document should start with your name and contact details, then a profile, before outlining your education, awards, skills, relevant experience etc. (not necessarily in this order).

Finally, a showcasing CV can tell a curator, client or potential collector about your achievements as a professional artist or designer. This will usually include thumbnail images, a mini-biography or art statement, awards, exhibitions, projects, commissions, publications, stockists, clients or collections and web presences.

When approaching a gallery owner with a hard-copy CV it is traditional for it not to include thumbnails of artwork.

In the illustration, animation and, to some extent, the film industry, a CV is useful, but usually art buyers, directors and clients are more interested in a short 'biog' and image sheet, postcards, showreel or portfolio.

You might also like to create a more unusual version of your CV – art directors have received knitted CVs, origami-like paper sculptures and mini-books in place of traditional paper versions.

RESOURCES

www.artquest.org.uk (how to create a CV)
http://careercv.mad.co.uk/
http://careers.guardian.co.uk/cv-tips-for-graduates
www.skillset.org
www.coroflot.com

Why should I enter competitions?

Undergraduates should enter student competitions, as winning awards, or even being shortlisted, are fantastic achievements. Doing well in competitions will secure exposure to key industry contacts and business opportunities.

List these achievements near the top of your CV so that potential employers or commissioning agents will see them immediately. If you win, or take another position, create a postcard with the award information on the back. This will subtly tell people about your accomplishments and increase the chances of attracting further commissions or sponsorship.

Media coverage can result in offers such as exhibitions or even a manufacturing or merchandising deal.

Once you have graduated, industry competitions can be expensive to enter, but it is essential to have a go. However, before doing so, view previous winning and shortlisted works online to check that the competition is right for you. Always add a © symbol followed by your name and the year to any drawings or designs, and keep a photocopy of the application for your records.

When you make an application, always read the terms and conditions carefully. Avoid entering awards that request the assignment of your copyright of your artwork, drawings or creative products. If planning to submit non-digital artwork, i.e. objects or models, make sure they will be returned to you at a future date.

RESOURCES

⤴ *Please refer to the relevant councils' websites listed in Q.1.*

www.artquest.org.uk ('Opportunities' or 'Deadline' sections)

Contact professional bodies and industry periodicals for further details.

How do I write a media release?

When you are trying to gain free media coverage for an exhibition, product launch or other project, the first issue you need to decide is what type of magazines and web portals will be interested in your story and why.

It is likely that you will require more than one version of the press release – perhaps several variations to suit different publications or news services.

The rules for creating an effective press or media release are:

1. It is usually less than 250 words.

2. Content is typed on one side of A4 paper.

3. It may include colour thumbnails and sponsors' logos.

4. Check that any photographs or images included print clearly in greyscale as most feature editors, journalists, critics and stylists use black and white laser printers.

5. Have other materials such as marketing copy, artist's statements and photographs as separate documents in both hard-copy and digital formats.

6. State what, where, when and why the event, award or launch is happening.

7. Explain that you are announcing a major showcase event, website or business launch.

8. If you do not have an event to announce, then think about how your artwork/product ties in with topical features such as Christmas gifts, new stockists, 'one to watch' features, wish lists, ecology, innovation, community news or regional festivals.

9. Remember when distributing press releases to check copy deadlines. For example, many magazines work three to five months in advance.

RESOURCES

Please also refer to Q.35, Q.36 and Q.43.

www.artquest.org.uk (see 'Press and Publicity')
www.artsmediacontacts.co.uk
www.writersandartists.co.uk
www.abc.org.uk

What is so important about self-presentation?

Art stars and design gurus can dress and behave more or less as they wish, although these mavericks are in the minority. When appearing in public at exhibitions, in the media and on television, the vast majority of professional artists and designers give a great deal of thought to their appearance.

Personal grooming is essential, even when still a student, and more so after graduation. I am sure that most of the student readers of this book will have external tutors and industry figures who periodically visit their department. Try not to be remembered by these potential agents or employers as the student who arrives late to lectures, forgets to bring a pen and notepad, or makes a presentation with hands stained with ink! The UK art and design industries are close-knit communities and when you later apply for opportunities or internships, you would not like to be recognised as the disorganised student from a few months before.

When moving from the student life to the professional world you might have to consider adapting or changing your image. This does not mean you have to become boring. It is traditional in design-aware sectors to develop your own personal style, but if you look like a student then it is more likely potential employers or clients might think that you do not have enough professional experience for the job or contract.

RESOURCES

⮌ *Please refer to the Further Reading section at the end of the book.*

Why is personal confidence such an issue?

When you leave college you will probably be excited about what the future holds. Self-confidence is an invisible asset in building rapport with others. It is also a vital personal quality when selling, presenting, pitching or negotiating a deal. However, it is worth realising that there is a fine line between being confident and being arrogant.

If, after graduation, you have met with immediate success, such as being offered a fantastic job or commission, then this will boost your morale even further. Such success can cloud your judgement, and it is important to understand that achieving long-term ambitions, especially in experimental, poetic or innovative fields, is uncertain. It is wise to keep your head together and not automatically assume such smooth career progression will continue.

Many artists and designers will tell you that they have had to overcome some degree of rejection when trying to make sales, succeed in competitions or apply for work. If you are in this position, then gaining feedback from established artists or designers about your CV, portfolio and promotional materials can be valuable. If things are not going well, it may be that the way you are presenting your creative products, artwork or services is deterring people.

Another reason for failure is simply the reality of tough competition from a large number of other traders or applicants.

RESOURCES

⊃ *Please refer to the Further Reading section at the end of the book.*

What are industry directories?

There are many types of contact books and industry directories in which you can advertise your artwork and creative services. Many of these volumes are circulated to art buyers, art directors, businesses and commissioning bodies. Most of the hard-backed portfolio catalogues that feature agencies or individual artists and designers are now also available online.

Some contact books, such as the *Art Book* and the *Creative Handbook*, only represent illustrators and image-makers who have an agent. Other directories, such as *Contact*, are for individual creatives. You should research which directory (or website) is best for you.

Many portfolio portals that are free to upload to, or charge only a small fee, have no quality control. You must consider whether you want your artwork on a website which also includes contributions from amateurs.

Certain industry directories, such as *AOI Images* and the *D&AD Annual*, have the benefit of being distributed to key creative/art directors and buyers. Being selected for inclusion opens the door to winning a cash prize and involvement in prestigious exhibitions.

Professional bodies and showcasing websites are other less costly ways to promote your work to a wider audience. However, you should still aim to be selected for the most well-known and respected publications.

RESOURCES

⮑ *Please also refer to the listings in Q.14, Q.44 and Q.47.*

www.axisweb.org
www.whitebook.co.uk
www.chb.com
www.dandad.org (see 'Talent')
www.aoiimages.com
www.ifyoucould.co.uk
www.theispot.com
www.behance.net
www.folioplanet.com
www.concretehermit.com
www.creativepool.co.uk
www.coroflot.com
www.bouf.com
www.photostore.org.uk
www.designnation.co.uk

How do I get my work or products into the media?

The budget solution is to visit your college library or a large newsagent and look through the magazines. Make a note of the names of relevant journalists, critics, reviewers, stylists, art directors and editors, then purchase the magazines in which you would like to gain exposure.

Television news programmes, radio shows and printed media require a constant rolling news cycle. However, too many press releases and images are received to all be included in their printed magazines, so it may be worth enquiring if they could add your story to their website. *For further guidance refer to Q.35, Q.36 and Q.39.*

Your first approach should be by telephone, unless stated otherwise on the publication's website or in media guidance. When you make the call, have all your materials, statements and prices in front of you, as they may request them immediately.

The more expensive, but professional, way is to invest in an *Arts Media Contacts* directory, which at the time of writing costs £115. This will give you all the information you require to organise a campaign.

Confidence, persistence and charm are essential in securing media coverage. If you find interest has been poor in your first marketing campaign, then consider doing something unusual such as a publicity stunt next time . *Please refer to Q.48 and Q.50.*

RESOURCES

www.thehandbook.co.uk
www.artsmediacontacts.co.uk
www.writersandartisists.co.uk
www.artquest.org.uk (see 'Press and Publicity')
www.a-m-a.org.uk

Why should I join a professional body?

Many artists and designers state that they do not find professional bodies useful. However, it could just be that they have not figured out how to make the most of them.

Professional bodies range in size, focus and activity. Some are good at organising workshops or giving legal guidance. Others have archives of learning materials and excellent online showcase facilities. Those with larger memberships have more resources and can run a variety of events and services. Membership of smaller guilds and associations is more like being part of a professional network that organises members' exhibitions and publishes a regular newsletter. *Please also refer to Q.42.*

If you can afford it, you could join several organisations to compare what they can offer you. Most professional bodies have different types of membership and special subscription rates for students. Most UK bodies are open to anyone who wishes to join.

I have always found that artists and designers who struggle to establish themselves are never members of professional bodies. It is likely that a lack of access to industry knowledge, and a failure to build networks among their contemporaries, hinders their ability to prosper. Finding organisations you can join in the first few years after graduation is an essential task and one that should not be put off.

RESOURCES

www.artquest.org.uk (see 'Networks')
www.taforum.org (trade body search)

Books
The *Essential Guide to Business for Artists and Designers*, Alison Branagan (London: A&C Black), includes a list of professional bodies.

How do I start networking?

The first step in building networks and a database of contacts is to set up your own pages on key social networking and micro-blogging websites. Then create further pages on several showcase/portfolio websites and sign up for e-newsletters from art and design support organisations.

Then you can begin the essential activity of developing contacts and friends in your industry. This can be achieved in several ways: subscribe to professional bodies, local art groups and business clubs; join or form a collective; gain invitations to private views and parties; or pay to attend conferences, fairs and prestigious networking events. Another way is to target people you would like to meet and gain an introduction to them. This could be achieved by an internship, or by more informal means through industry contacts.

Allocate a large proportion of time in the first year of starting a business for networking. When attending any networking opportunities it is essential that you take professionally printed business cards and make the effort to speak to as many people as you can. If you have come to rely on email as a means of communication, the prospect of speaking to people may seem overwhelming. However, it is essential to retain oral communication skills – building rapport with people in your industry is half the battle when developing a client base.

RESOURCES

Please also refer to Q.1, Q.14, Q.42, Q.44 and Q.47.

www.facebook.com
www.linkedin.com
www.creative-enterprise-network.com
www.youtube.com
http://shootingpeople.org
http://chinwag.com
www.archiportale.com
www.a-n.co.uk (National Artists' Network)

Do I need a website?

At the time of writing, it is still usual for artists and designers to have their own websites. Leasing your domain name from a hosting company is something you should not put off. If funds are limited then you should at least 'rent' a domain name (this is known as 'parking'). Once you have paid to park your name, it means that no one else can use it to set up a website. Then, when you can afford it, you can 'host' and design your website.

Having your own website is crucial for promotion and other services such as e-trading. In the future, who can tell what other functions websites might have: 3D imagery, instant printing where customers pay and manufacture the product at home, who knows?

Alternatively, it is worth bearing in mind that there are many ways to build your presence on the internet either without, or alongside, your own website. There is a wealth of online showcase portals, portfolio websites and online galleries. Some of these are free, while others require an annual subscription.

Avoid buying cheap template website packages and invest in a professionally designed website. Three to five stylish pages are more desirable than dozens of uninspiring template pages. If you are planning to sell artwork, creative products or services from your website, make sure you comply with the Data Protection Act and the Distance Selling Regulations.

RESOURCES

Please also refer to Q.32, Q.36, Q.47, Q.51 and Q.70.

www.oft.gov.uk
www.tradingstandards.gov.uk
www.ico.gov.uk
www.w3.org
www.seo-blog.com

Q47

Where should I showcase?

This is a critical question. Most artists and designers still need to exhibit in bricks and mortar venues as well as online. But an exhibition strategy that works for other creatives may not be right for you.

In the first few months, and even years, it is always worth having small shows in local venues, and taking part in community festivals and group exhibitions. Avoid, where possible, paying to hire a venue as it is unlikely you will sell many artworks and creative products or cover even basic costs.

To be successful when exhibiting in professional galleries, collective shows or trade fairs it is vital to have experience in organising and marketing your show by building a database of contacts, solving any technical or digital presentation problems, and taking out appropriate insurance. ➲Please refer to Q.65.

Research is essential. Avoid rushing into hiring a stand at a major fair or approaching a gallery until you have visited the venue or event at least once.

The best trade, retail and art fairs are so well attended that they are booked up at least a year in advance. However, sometimes they will offer 'starter stands' for fledgling artists and designers. They might also be able to offer a stand or space at the last minute due to a cancellation. Always beware of taking up last-minute offers or being seduced by slick salespeople offering a 'deal'. Among the most important elements of exhibiting at fairs is being in the catalogue/event guide and the online directory, increasing the chance of being included in the official promotional campaign. Last-minute bookings will mean it is unlikely you will be in any of these.

The best research you can do as a student, or before you start your business, is to visit all the major shows and fashionable fringe fairs, so that in the future you can plan which exhibitions, competitions or shows would be most advantageous for you.

Taking part in fairs is expensive, so you might make a loss, or only break even at the first few shows. Many buyers and collectors will only purchase after you have established yourself, which can take two to four years. Seek advice from business advisers or seasoned exhibitors about how to present your stand and how to turn visitors who express a vague interest in your work into clients.

RESOURCES

🡒 *Please also refer to Q.1, Q.19, Q.20, Q.21, Q.24, Q.42, Q.44, Q.50 and Q.65.*

www.artquest.org.uk (see 'Venues')

Venue listings
www.allinlondon.co.uk
www.britisharts.co.uk
www.artswales.org.uk
www.walesdirectory.co.uk
www.discovernorthernireland.com
www.creativescotland.com
www.scotland.com

Why should I invent publicity stunts?

Raising your profile in the media requires a great deal of investment. But paying for expensive marketing campaigns can drain finances and may not be as effective as adopting a more unusual strategy. Whether it is embroidering your CV on a sampler, or walking around town wearing a painted sandwich board and a silly hat, an imaginative approach to self-promotion will yield more press and public attention than placing adverts or gaining editorial coverage.

Over the years, many artists and designers have adopted alternative approaches to securing press attention. Examples include Salvador Dali's eccentric appearance, Yves Klein's fake picture of himself leaping off a wall, Zandra Rhodes' pink hair and Banksy's undercover art activities and his infamous anonymity.

Admittedly, crazy stunts can backfire, but it might be worth taking a few risks to achieve a memorable effect.

If you do plan a stunt, send a media release to the press and set up a photo call. This may be an ambitious request if you are relatively unknown, but you should rehearse the stunt beforehand and commission professional photographs to send to newspapers in case no photographers turn up. Then simply email either high or low resolution images (or a short film) of the stunt, so that journalists can print them or upload them to the web.

RESOURCES

Please also refer to Q.36, Q.39, Q.43 and Q.65.

www.borkowski.co.uk
www.creativereview.co.uk
www.thejackdaw.co.uk
www.youtube.com

Q49

What is sponsorship?

A sponsor is a person or organisation that finances or provides other resources or goods in return for advertising. There are many art and design awards that receive major sponsorship such as the Jerwood Contemporary Makers' Prize, Adobe Design Achievement Awards, and the Veolia Environnement Wildlife Photographer of the Year.

Commissions, fairs and other shows are sponsored by numerous patrons. These include charitable foundations, banks and car manufacturers; insurance, petroleum, software and telecommunications companies; and producers of alcoholic and non-alcoholic drinks.

However, you do not have to run a national event to gain support from businesses, arts councils or charities.

If you are short of funds for your degree show, exhibition or community art project, you can gain support in the form of money or resources from businesses or organisations in return for reproducing their logo on press releases, signage, posters, postcards or tickets. ➲*Please refer to Chapter 8, Funding and Sponsorship, in the* Essential Guide to Business for Artists and Designers *for more guidance (see the Further Reading section at the end of the book).*

Find out the name of the person who deals with these requests and, if you are only looking for several hundred pounds or small amounts of materials, telephone them about eight months before your event and enquire if they would like to be a sponsor. Then post a follow-up letter including a draft press release and selected images.

If you need more than £1,000, then submit a more formal sponsorship proposal to the business or organisation 12 and 18 months before you need it.

RESOURCES

Please also refer to resources in Q.1, Q.36 and Q.81.

www.artsandbusiness.org.uk
www.hollis-sponsorship.com
www.dsc.org.uk
www.acf.org.uk
www.turn2us.org.uk

How much time and money should I spend on promotion?

Do not underestimate the complexities of attracting visitors or gaining customers, collectors and clients. Bear in mind, too, that the prospect of achieving what you want is uncertain. It may take much trial and error before you discover which strategies work for you.

Before spending any money, always gain feedback on draft marketing plans, materials or website designs from tutors, business advisers, mentors, other established creatives, and potential clients or customers.

Next, undertake a few trials. Set a small budget and promote a recent achievement, such as completing a large commission, in different ways to see which strategy works best.

As creatives establish themselves, the amount spent on marketing usually increases as they become more successful, and this should be reflected in the quality of their marketing materials.

Whatever you do, do not under-invest in yourself. Poorly designed and produced materials can undermine your professionalism. Alongside planning media campaigns, you may have to undertake regular monthly or quarterly mailshots to current and prospective clients.

It is advisable to reinvest 10% of your annual profits into marketing activities. However, predicting what you need to spend is not an exact science and devising a marketing plan with estimated costs is a useful exercise at the start of each financial year.

RESOURCES

Please also refer to Q.34, Q.35, Q.36, Q.42, Q.46 and Q.47.

Legal

Q51

Why do I need a working knowledge about legal matters?

Setting up as a sole trader (self-employed), as a member of a partnership, or as a limited company, requires not only a thorough understanding of the regulations governing your form of business, but a far-ranging awareness of the raft of laws applying to the visual arts and creative industries.

Failure to grasp some basic legal principles before you start a business will increase the likelihood of your being ripped off, fined, sued, banned or imprisoned. There are many more laws today than there were even two years ago. It is therefore vital to seek professional advice from a business adviser with experience of your art form or industry sector, a solicitor specialising in intellectual property rights, and from an accountant. You should also join an appropriate professional body.

This section gives the briefest of introductions. As this is a complex subject, a number of useful websites are listed here.

RESOURCES

⤷ *Please also refer to Q.44 and Q.65.*

www.companieshouse.gov.uk
www.bsi-global.com (British Standards)
http://shop.bsigroup.com
www.businessstandards.com
www.newapproach.org (CE marking)
www.lightingassociation.com (guidance on CE marking)
www.btha.co.uk (Toys)
www.kitemark.com
www.cen.eu (European Committee for Standardisation)
www.iso.org (International Standards)

http://envirowise.wrap.org.uk
www.britishcopyright.org
www.own-it.org
www.ipo.gov.uk
http://oami.europa.eu (European Harmonisation Trademark and
Design Right)
www.wipo.int
www.a-n.co.uk
www.creatorsrights.org.uk
www.start.biz
www.bis.gov.uk
www.tsoshop.co.uk
www.hse.gov.uk
www.oft.gov.uk
www.tradingstandards.gov.uk/advice
www.lawsociety.org.uk (lawyers for your business scheme – free)

What is copyright?

At the time of writing there is no international copyright law, but there are international agreements such as the Madrid Protocol and the Berne Convention, which require countries to recognise each other's intellectual property laws. Copyright laws vary from one country to another, and though the rules may differ, the governing principles are similar.

Copyright governs the rights of artists, designers, photographers, film-makers, musicians, authors and performers. When you create an artistic work you have both the physical object and the copyright in it. But the original artwork and the copyright are two different matters. For instance, an artist usually sells a painting but retains the right to reproduce it, whereas an illustrator usually keeps the original drawing but licenses or sells the copyright.

In the UK, copyright is automatic and usually lasts for life, and continues for 70 years after the author's death. There are variations, for example in respect of broadcast and recording rights, which are protected for 50 years from the end of the year of first publication, performance or broadcast. Typographical arrangements in a graphic layout are protected for 25 years from the date of first marketing/publication.

It is worth understanding that you own your own copyright unless you are an employee. Then it is usually the employer who owns the copyright on all your creative output. When self-employed, you own your own rights. But do take care, when undertaking any freelance assignments, to ensure that your client or customer's contract does not seek to take more rights than you are prepared to grant. ➲ *Please also refer to Q.53, Q.54, Q.58, Q.59, Q.62 and Q.96.*

RESOURCES

www.ipo.gov.uk
www.artquest.org.uk/artlaw
www.dacs.org.uk

How do I protect my rights?

Copyright and unregistered design right
In the UK at the time of writing you do not need to register copyright for an artistic work. The same applies to the 'unregistered design' right, which is like a lazy version of copyright, but for products. Unregistered design right in the UK lasts 15 years from the first drawing or prototype, and only 10 years from the date an item is first marketed.

Retaining records
It is important to keep a properly organised archive of sketches, photographs, plans, source materials, models or early drafts. Make sure you date and sign sketches, paintings or other artworks and designs. This is essential when trying to assert your rights and prove that you are the original maker. Equally, retaining records will help you defend yourself against any allegations of copying from other artists, designers or businesses.

If you have many digital files stored in a computer or on back-up media, it is vital to print these images on paper and store them together. Remember to make use of the copyright symbol © as much as possible, such as on your website, in presentations or other proposals. If you form a good working relationship with a local intellectual property solicitor they should be prepared to hold date-stamped copies of artworks, designs and inventions on your behalf.

Registered design right
To gain protection in the market, designs including textiles/fabric patterns can be registered at the Intellectual Property Office (IPO). If your design or prototype is deemed original enough, you will be granted protection for up to 25 years, which can be renewed every five years. *Please also refer to Q.25, Q.55 and the following section.*

Know-how
You can simply keep particular areas of industry know-how, such as recipes or working methods, as trade secrets. *Please also refer to Q.57.*

Patents

You can apply to register a patent to protect novel inventions, formulas/recipes, or the processes involved in making a new material.

If you think you have an innovative idea, diagram or prototype you should not reveal it to anyone until you have spoken to an intellectual property solicitor or patent agent. Even then you should not disclose anything to anyone until your invention has been filed as an 'initial application' for one year (there is no fee for this). Only then can you discuss the invention openly, and exhibit your product at degree or trade shows, etc. Once a patent has been granted it can last up to 20 years.

It is essential to make use of Non-Disclosure Agreements (NDA) when speaking to potential investors, manufacturers, or, indeed, any third party.

Business, brand, product names and other marks

Business, brand and product names can be initially protected in the marketplace by using the symbol ™. These letters indicate that you are using a name as a business or brand name. To gain full protection, you must register your name as a trademark with the Intellectual Property Office (IPO).
⮑ *Please also refer to Q.5, Q.34 and Q.56.*

RESOURCES

⮑ *Please also refer to Q.96 and the resources in Q.1, Q.51 and Q.52.*

http://acid.eu.com
www.fdpa.co.uk
www.artmonthly.co.uk (see Henry Lydiate's column)
www.lpaware.net

What is a licence?

A licence is a written contract that confers the right to do something, for example reproduce an artwork, manufacture a product or grant a patent licence. Licences can be agreed for a fixed fee, a fixed fee plus a royalty, or on a royalty only basis. The licence is limited by purpose or use for a period of time, i.e. for 24 hours, three months, three years, or for the length of copyright. You and the other party/client can also agree about what territory the licence covers, for example UK only.

Four elements to remember

1. Money: fixed fee or/and royalties?

2. Purpose: how it can be used?

3. Duration: how long?

4. Territory: where it can be used?

'Assignment' means selling your copyright outright to the client. Always try to avoid signing away your copyright and negotiate a licence instead.

You should always try to obtain an origination fee for the creation of the work and then charge a second fee or agree royalties on the basis of what, where and for how long the client wishes to use the artwork or designs. Sometimes it is difficult to separate the two. Many creatives do quote fees solely based on how the artwork is to be used. However on the creator's part it is far wiser, where possible, to treat the origination fee and agreements for how it will be used as two separate matters. *Please refer to Q.74 for more detail.*

RESOURCES

For further guidance contact your professional body and also refer to the listings in Q.52, Q.53, Q.58, Q.59, Q.62, Q.74, Q.76, Q.77, Q.78 and Q.96.

Q55

Why should I apply for design right?

As mentioned in Q.53, it is vital to gain protection for your designs that have the best commercial potential. A registered design right protects the outward shape of the product or design and its ornamentation, colour, texture or pattern.

If granted registration in the UK, it means you will have exclusive rights to manufacture, import, sell, or license the design within the territory in which you registered the design. If beginning to export to countries within the European Union (EU), you could apply for Registered Community Design. It is possible to gain protection in countries outside the EU, though this can be costly and may be unnecessary.

Always seek advice concerning design right before you register any designs. Only an experienced intellectual property solicitor will be able to advise you whether it would be a good idea to register your designs in other countries. The reason why you should seek advice the moment you decide to register is that there are different agreements concerning design right with other countries. You may be able to claim a priority right regarding design registration in these countries within a fixed number of months.

The other key matter is that under UK design right registration law you have up to one year from the moment you create your design, product or textile or from first marketing it – for example, at a degree show or trade fair – to register it. After a year you can no longer register that particular design. It is worth knowing that you only gain protection from the moment you apply to register a design or product.

Once you have registered your designs in the UK or EC they will appear on the website of the Intellectual Property Office (IPO).

Should you succeed in gaining UK or EC registration, then you will have additional powers (under the Registered Design Act of 1949) and other subsequent laws over others who attempt to copy or sell counterfeit versions of your products.

If you discover a retailer is selling goods the same as, or very similar to, your own design, say nothing. Buy one example and contact an intellectual property solicitor. If the solicitor agrees that your registered design right has been infringed, they will then write to the store or individual concerned and request that they desist from selling the items and 'render them up' (deliver them) to the solicitor's office or to your studio. But do not put off taking action, as any delay could materially affect your ability to enforce your rights.

There are, of course, fees involved in enforcing your registered design right. But, if you are serious about protecting your designs, you have to be prepared to invest money in defending your design right.

RESOURCES

Please also refer to Q.53, Q.54, Q.60 and Q.96.

http://youthoughtwewouldntnotice.com/blog3
www.counterfeitchic.com
www.spotcounterfeits.co.uk

What are trademarks?

A trademark can be many things: a designer or artist's own name, a business name, a maker's mark or monogram, a brand name for a product or service, a logo, motif or image, a jingle, smell, slogan, 3D shape or colour. Do not underestimate its potential value. It is an invisible asset, a name or mark associated with a trade, which is a unique badge that distinguishes a business and its products or services within the marketplace.

You should, if possible, undertake thorough market research before deciding on a name or business name to use before registering your business with HM Revenue & Customs (HMRC) or with Companies House. Using the same name as, or a name very similar to, an established limited company or a registered trademark is seriously unwise.

Putting off registering your business/product name or branding is potential commercial suicide. If you leave it, a competitor could apply to register that name with the Intellectual Property Office (IPO) as a trademark in the same area of trade, and he or she – not you – would have the exclusive right to exploit (in other words use) that name or brand in the territory for which it is registered.

Remember, you must not use the ® symbol until you have gained registration. Before or during the registration period you can use ™, although this can in fact attract unwanted attention to a mark that is not yet protected. Always seek expert advice on your specific needs.

RESOURCES

Please also refer to Q.9, Q.34 and Q.96.

www.ipo.gov.uk (note that the trademark search is complicated)
www.start.biz (easy-to-use business name search engine)
www.uktrademarkregistration.com (free trademark search)
www.companieshouse.gov.uk

Why should I keep inventions secret?

If you intend to file a patent in the UK, EU or elsewhere in the world, you will invalidate your claim if you reveal your idea, design or prototype to anyone apart from an intellectual property solicitor or a patent agent.

You may decide, after taking professional advice, that seeking protection by filing a patent is not the best course of action. However, remember that the Intellectual Property Office (IPO) does not charge a fee for filing an invention/prototype or diagram as an initial application for one year.

However, once a patent is granted (after 18 months), all technical information regarding your invention is available to anyone to see on the IPO website. Many firms opt to keep recipes, technical processes and other industrial know-how as trade secrets rather than seek protection by obtaining a patent. You may have invented a material or technical process that is not patentable and could be best protected by remaining a secret. It is always worth checking with an intellectual property solicitor or patent agent whether it would be wiser to file a patent.

Many creative businesses that have technical know-how stretching back many decades, if not centuries, such as the Madame Tussaud's workshops, protect their expertise by requesting employees or freelancers to sign secrecy agreements.

To be able to enforce such agreements they have to be well drafted, so take the appropriate level of advice at all times.

RESORCES

➲ *Please also refer to Q.1, Q.29, Q.53 and Q.96.*

www.ipo.gov.uk
www.bl.uk
www.innovationuk.org
www.britishinventionshow.com
www.thebis.org
www.cipa.org.uk

What is the relevance of terms and conditions?

If you regularly work for a number of different clients, supply numerous shops, or take on commissions or sell products from a website, then it is strongly advised that you have your own terms and conditions. All sorts of things can go wrong when completing an order or commission, so it is vital to limit your personal liability by investing in a properly drafted set of terms and conditions.

Most established artists and designers have terms and conditions on their websites. However, if trading online, many creatives have one set governing their online activities and another set for retailers or private commissions.

When you send your terms and conditions to a client, their silence may indicate acceptance. Nowadays, it is wise to double-check confirmation of your terms by telephoning them, or – better still – get written confirmation. By the same token, if a client sends you a set of terms and conditions, your silence will be interpreted as acceptance. If you receive a set of terms after the client has received yours, then unless agreed to the contrary, the last set of terms governs the relationship or 'informs the contract'. This situation is known as 'the battle of the forms'.

Problems occur when artists and designers do not read clients' terms and conditions properly and fail to raise any concerns.

RESOURCES

⭢ *Please also refer to Q.59, Q.60, Q.61, Q.70, Q.90 and Q.91.*

Contact your professional body to check whether model terms are available. www.silvermansherliker.co.uk offers a free initial consultation session and affordable UK legal document solutions

www.a-n.co.uk

What is the point of having a contract?

A 'contract' results from an 'offer' and an 'acceptance', requiring something in 'consideration', which is usually money.

A contract can be made as the result of a discussion. If such a discussion is not put into writing it is referred to as a 'verbal agreement'. The key problem with verbal agreements, especially when working on a creative project with others, is that the parties can fall into dispute over rights or how to turn the idea into a commercial concern. This is particularly true of informal collaborations that result in innovative art or design ideas which, if exploited, may be highly profitable. In reality, it is unwise to rely on a verbal contract because people's recollections vary, especially after time.

This is why it is important to have written agreements, or formal documents such as a deed of partnership, joint venture agreement or shareholders' agreement, before starting any joint project, no matter how casual.

Most professional artists and designers have their own contracts. Model contracts can be obtained from most professional bodies as part of membership. Alternatively, you can have your own set of contracts drawn up by an intellectual property solicitor. There are many different types of contracts and documents that creative businesses require. These could include several of the following:

1. Terms and conditions.

2. Shareholders' agreement or deed of partnership.

3. Acceptance of a commercial commission.

4. Private commissioning contract.

5. Order forms.

6. Sale or return agreements.

7. Licensing agreements.

8. Model release forms.

9. Non-disclosure agreements.

A written contract will help collaborators, partners and clients understand clearly what the agreement is; what artwork, creative products or services have to be made and delivered; the ownership or licensing of intellectual property rights; as well as any sums of money involved, including liabilities, roles and responsibilities.

Avoid simply copying and pasting online versions of other artists' and designers' terms and conditions into yours. You do not know the origin of these documents and they may not be legally sound. Furthermore, you may well be infringing someone else's copyright!

Having professional contracts drawn up may seem expensive, but could save you considerable outlay in the long term. Going into business is a serious matter and without having proper agreements in place at the outset, you may quickly find yourself embroiled in legal disputes that could otherwise have easily been avoided.

RESOURCES

Please also refer to Q.3, Q.51, Q.52, Q.58, Q.60 and Q61, and the Further Reading section at the end of the book.

Why should I read a contract?

You may be surprised to know that many artists and designers do not bother to read a client's terms and conditions or contract properly, if at all. This lack of scrutiny often leads to trouble. When you receive any form of agreement it is essential that you print the document out, if it has not been sent by post, read it carefully, and make notes as you go.

Initially, you may not fully understand what some clauses mean, as contracts tend to be written using precise legal wording. Unless you have had some guidance or training about what key legal terms mean, it is easy to be completely baffled by what parts of the agreement mean in practice. So read it through in its entirety once before trying to understand individual clauses or provisions.

When making business agreements, the commissioning agents usually do not have much to do with the legal side of the business. It is common to have a pleasant, informal chat about a project only to find that when the contract arrives it does not reflect the spirit of the oral agreement. Don't simply accept what is put in front of you if it appears wrong. Do not sign anything you do not understand.

Until you become more familiar with legal terms, seek advice about contracts from your professional body, intellectual property solicitor or an experienced artist or designer. There could be some unacceptable clauses in the contract that limit your ability to trade, take away your control or ownership of your intellectual property rights, or leave you exposed to personal financial liability. Identify any problem areas sooner rather than later.

RESOURCES

Please refer to Q.16, Q.58, Q.59, Q.61 and the Further Reading section at the end of the book.

What should I do if I do not agree with a contract?

If there are clauses you do not understand or agree with, seek professional advice. Do not be afraid to contact the client directly and talk through your concerns. Do not simply accept what appears in front of you; it is essential that you only sign a document if you fully understand and agree with its contents. You can negotiate and amend terms and conditions as well as stand-alone contracts. If you discuss your concerns with the client they may propose a more acceptable set of terms or a revised contract.

Alternatively, they may ask you to send back the original terms or contract with your amendments by post beforehand. In that event, either strike through the offending clauses or amend clauses in black ink, and in either case write your initials next to the clauses concerned at both ends of the line. If the document is a contract, then sign it where indicated and write clearly next to your signature 'Agreed subject to the striking out of clause x, and z, and amendments to a, and b, etc.'. Then return the document to the client with a friendly covering letter, saying that you would like to proceed, although only on the basis of the amendments suggested.

Ideally, you should receive an acceptable revised contract. Always make sure that both parties sign this contract to avoid any risk of ambiguity. Where a company sends you two copies of the contract pre-signed, sign both copies, retain one copy and post the other back. If you find no signatures, sign both copies and post them back to the company. They will then post you back one of the original versions after they have signed both of them.

Remember to always keep one of the original versions of a client's terms, and other subsequent contracts, with your business records.

RESOURCES

Please also refer to Q.58, Q.59, Q.60 and the Further Reading section at the end of the book.

Q62

How do I spot a rights grab?

A 'rights grab' is an informal industry expression that describes various phrases you may find in a client's terms and conditions or contract which attempt to transfer the ownership of your copyright to them.

Many hard-nosed businesses often start the commissioning process with a tough negotiating position.

To protect yourself, the first thing you should do is check the prospective client's terms and conditions. Then look at any subsequent provisions, whether contained in contracts, correspondence or attachments. The first contract you receive is sometimes referred to as a 'standard' contract. If you see the word 'standard' in a contract then it is quite likely that it states the business wishes to 'own' your copyright, that is, 'assign', 'transfer' or 'buy' your 'rights' or 'copyright'. These types of terms are all potentially rights grabs.

Once you have assigned your copyright to someone else, that is it. You cannot even use the commissioned work for your own purposes. You will not be able to negotiate on future uses or further fees – the commissioning party will own the copyright outright. The exception to this is if the terms or contract did not demand ownership of the original artwork, in which case you will be able to sell it.

You should also avoid granting an all-encompassing worldwide 'exclusive licence' for all time. This is more or less the same as 'assignment'.

It is worth noting that in contracts that commission works of design, it is usual that 'unregistered' design right rests with the client or commissioner. If you are unhappy about this situation, you can try to negotiate your retention of these rights.

RESOURCES

Please also refer to Q.52, Q.53, Q.54, Q.58, Q.59, Q.63 and the Further Reading section at the end of the book.

What should I do if I have been ripped off?

If you are confident that your artwork or design has been copied, it is important that you say nothing to the individual, business or organisation concerned. Do not communicate with them in any form. At the same time, do not be put off taking decisive action immediately, as any delay can be fatal to your claim.

Quickly arrange a meeting with an intellectual property (IP) solicitor and show them your research/sketches/CAD files and the original artwork, design, logo or creative product together with some form of record of the offending article, such as a sample purchase, website screen shot or a photograph.
➲ *Please also refer to Q.55.*

It is important that you seek an expert opinion from an experienced IP solicitor as to whether your work has been copied or not. It can be difficult to justify if the offending artwork or design has an appreciable number of differences to your original work. It could just be a coincidence that someone else has created a work similar to yours, especially if the other work has more differences than similarities to your own.

The IP solicitor will tell you whether or not to take action. There will be costs involved, but it is essential that you ask the solicitor to act rather than continue to let others pass off your artworks, designs, branding or product as their own.

It may not simply be under copyright law that objections could be raised. You may be able to take action under the UK or European Community unregistered design right laws. EC unregistered design right law lasts three years and can represent a more sympathetic set of legislative measures for those who have had artwork, designs or patterns copied by infringers.

If you have registered a name, business name, logo, symbol or image in connection with your business as a trademark, then you may well be able to take action against infringers under trademark law. In some cases involving registered companies, another artist or designer may have set up as a sole trader with the same name long after you established your business or brand name in the marketplace.

About 95 per cent of all copyright, design right or business name disputes are settled by sending out a solicitor's letter. It is rare that individuals or businesses caught copying will want the matter to the settled in the courts. The risk of adverse publicity may well be sufficient to enable you to settle on acceptable terms.

RESOURCES

Please also refer to Q.1, Q.9, Q.52, Q.53, Q.55, Q.58, Q.59 and Q.62, and the Further Reading section at the end of the book.

Tell me about DACS

DACS stands for the Design and Artists' Copyright Society. It is an organisation that distributes money to designers and artists from various sources – referred to as 'Payback' – and provides other rights management services.

British artists and designers can receive money if they have had photographs, images of artwork or photographs of their products featured in books, magazines and television programmes. The Payback registration process is straightforward and can be completed on the DACS website (go to www. dacs.org.uk).

DACS also administers artists' resale rights. These are a percentage of the resale price of artworks, sculptures, limited-edition prints, collages, photographs, and 'unique' traditional craft or applied art pieces, such as tapestries, textiles, jewellery, furniture, glass or ceramics. They are paid when artworks and one-off pieces are resold though a dealer, agent or auction house for more than €1,000. This right lasts for your lifetime and for 70 years after your death. See the DACS website for registration and further information, including a full list of eligible artefacts.

Artists and designers living within the EU can benefit from resale rights. Contact DACS for more details of its activities and services.

RESOURCES

www.dacs.org.uk
www.creatorsrights.org.uk
www.artquest.org.uk/artlaw

Q65

What insurance do I require?

Certain types of insurance are a legal requirement, while others are sensible safeguards for any professional creative to have.

If you do not have appropriate insurance, you could be liable for paying damages and hospital bills and replacing expensive objects or equipment. It is possible to be sued for many hundreds of thousands of pounds if your product is shown to be faulty, or if you have caused an accident while providing a service.

It is essential that you take out public liability insurance if you are going to do any of the following: hold an event or performance on private, public or business property; trade at a market stall; host an exhibition or take part in a design fair; teach workshops; paint murals; or install sculptures.

If you are selling artworks or other creative products, then it is similarly wise to take out product liability insurance in case they cause unforeseen harm or damage.

If you are planning to trade from home or business premises, it is vital that you seek advice from a good insurance specialist. If you are about to start trading from home, contact your home insurance company to discuss your plans. It may be worth investigating a 'home worker's' insurance package.

If you are seeking insurance cover for a number of activities, e.g. you are a self-employed photographer or film-maker, explore the benefits of an 'all risks' policy.

It is also sensible to check whether you need professional indemnity insurance when providing a business service such as marketing, branding or IT advice; logo and sign design for businesses; or guidance that may have a health and safety implication, for example when starting a business as an architect.

Professional bodies sometimes provide membership insurance deals. If they are not in a position to help, contact a business adviser with knowledge of your industry sector.

RESOURCES

Please also refer to Q.8, Q.17, Q.18 and Q.26.

www.a-n.co.uk
www.saa.co.uk (free public and product liability insurance deal)
www.nmtf.co.uk
www.artquest.org.uk
www.fsb.org.uk (list of brokers)
www.biba.org.uk

What is so important about safety?

There are dozens of regulations concerning health and safety. Some of the most important ones are:

1. Health and Safety at Work Act (HASAWA), 1974 (and its many revisions and additions).

2. Control of Substances Hazardous to Health Regulations (COSHH,)1988.

3. Reporting of Injuries, Diseases and Dangerous Occurrences Regulations (RIDDOR), 1995.

4. Electricity at Work Regulation, 1989.

5. The Personal Protective Equipment at Work Regulations, 1992.

6. The Manual Handling Operations Regulations, 1992.

7. The Provision and Use of Work Equipment Regulations (PUWER), 1998.

8. The General Product Safety Regulations, 2005.

All artists and designers need to know about health and safety law as the legislation applies to visitors coming to your studio, and the design and construction of creative products, artworks, installations and performances as well as your own activities. It also applies to you when teaching a workshop and trading from a market stall, retail unit, gallery or at a fair.

Safety is really about common sense, such as storing materials and tools properly and making sure hazardous chemicals are labelled correctly. It requires that you wear appropriate protective clothing, ask for help when handling heavy objects, and do not work when feeling tired.

It is advisable to attend a short course on health and safety, especially if you intend to work in studio administration, art colleges, theatres or other 'hazardous' environments. Courses are held by adult and further education colleges, or contact the Health and Safety Executive (HSE) for advice.

RESOURCES

Please also refer to Q.67.

www.hse.gov.uk
www.a-n.co.uk
www.bsieducation.org

What are British Standards and CE marking?

By law, products sold in the UK and EU must comply with relevant standards. These include CE (European Conformity) marking. Other regulations applicable to designers who wish to trade in the EU include fibre content labelling, environmental and packaging regulations. ⮑*Please also refer to Q.68.*

If you are a British designer, an EU citizen or have a visa to trade in the UK, then check with the British Standards Institute or your professional body to see if you are required to self-certify your products or have them tested independently. Such regulations apply to electrical goods, soft furnishings, clothing, craft kits, watches, toys and furniture, among others. Failure to comply with these regulations could make you subject to prosecution by your local trading standards office.

Whether you live within the EU or outside it, for example in the US, check with international or European organisations for standardisation. If you are a designer living outside Europe, you will be unable to legally sell your products within Europe and many other countries if your product does not comply with European and international standards for safety and quality.

If you want to sell your products outside the EU, for example in the US, check that they meet with international standards for safety and quality.

RESOURCES

⮑ *Please also refer to Q.51, Q.68 and Q.70.*

British Standards
www.bsieducation.org
www.bsigroup.com
http://shop.bsigroup.com
www.businessstandards.com
www.bis.gov.uk

European Committee for Standardisation
www.cen.eu

International Organisation for Standardisation
www.iso.org

International Electro-technical Commission
www.iec.ch

CE marking
www.newapproach.org
www.lightingassociation.com (for guidance on CE marking)
www.fira.co.uk
www.bfm.org.uk
www.upholsterers.co.uk
www.btha.co.uk (toys)
www.kitemark.com
www.incpen.org

Q68

How do environmental regulations apply?

Environmental legislation has been introduced to oblige businesses to minimise waste, recycle materials, and to reduce pollution and energy consumption. Within the EU, there are numerous environmental regulations. The key ones include:

1. Packaging (Essential Requirements) Regulations, 2003, amended 2004 and 2006.

2. Hazardous Waste (England and Wales) Regulations, 2005.

3. Environmental Protection Act, 1990.

If you are working with hazardous chemicals, solvents or similar materials, then contact your local council to find out how they can be disposed of safely.

An important set of regulations for most creative businesses concerns packaging. Any businesses trading within the European community is now legally obliged to ensure that all packaging is recyclable or made from recycled materials. The design of any packaging should eliminate waste and minimise weight and volume.

RESOURCES

Please also refer to Q.67.

Contact your local council.

www.foe.co.uk
www.wrap.org.uk
www.netregs.gov.uk
www.recyclenow.com
www.envirowise.wrap.org.uk
www.fsc-uk.org
www.eco-label.com
www.green-mark.co.uk
www.iso-14001.org.uk
www.incpen.org
www.bis.gov.uk

What is a CRB check? What is the ISA?

A criminal records check, carried out by the Criminal Records Bureau (CRB), is a check that employers make on potential job applicants to check whether they have a criminal record.

Generally speaking, in the UK, if you wish to join an agency supplying artists and designers to schools, hospitals, care homes or prisons, the business, arts organisation or local council for whom you will be working will usually run a CRB check on you and charge you a small fee to cover administration costs. In Scotland and Northern Ireland it is also possible for private individuals to apply for a basic disclosure or criminal conviction certificate.

The Independent Safeguarding Authority (ISA) is a new body with a registration scheme for authors, artists and designers who regularly visit or run workshops in schools in England, Wales and Northern Ireland. If you are only making a one-off visit you may not have to pay the £64 registration fee, but if you are heavily involved in community arts projects, and regularly work in schools, registration was made compulsory at the end of November 2010 and you should contact the ISA for more details. A separate scheme is operating in Scotland from 2011. (At the time of writing, this registration scheme is under review.)

RESOURCES

www.crb.homeoffice.gov.uk
www.isa-gov.org.uk
www.accessni.gov.uk
www.disclosurescotland.co.uk
www.scotland.gov.uk

Do other regulations apply to me?

You may already be aware of the numerous laws that apply to your business. But, as new laws seem to come into force every week, it is important that you get advice about the legal issues that apply to your business as soon as you register as self-employed or form a partnership or company. Many businesses break regulations simply because they are unaware of their existence. The Consumer Protection (Distance Selling) Regulations of 2000, which govern sales from websites, is one key piece of legislation you need to be aware of.

The Data Protection Act of 1998 applies to any business that retains personal contact details of its clients and customers, either as digital or paper records. You may need to register with the information controller, especially if you have compiled a database for any business or marketing purposes.

The UK Hallmarking Act of 1973 and subsequent amendments cover jewellers and silversmiths. A hallmark is a combination of the maker's mark, a metal fineness number and an Assay Office mark. Other optional marks include the traditional fineness symbol and date mark. **Unless specifically exempted**, all gold, silver and platinum articles offered for sale in the UK must be hallmarked.

It is also worth remembering that while some industry rules are not enshrined in legislation they can be universally recognised within your area of trade. (A good example of this is 'above the line' and 'below the line'.) *Please see Q.74.*

RESOURCES

Please also refer to the resources in Q.1, Q.51, Q.58, Q.67, Q.68 and Q.69.

www.oft.gov.uk
www.ico.gov.uk
http://theassayoffice.co.uk
www.britishhallmarkingcouncil.gov.uk
www.assayofficescotland.com
www.thegoldsmiths.co.uk
www.fineart.co.uk
http://ukft.org
www.bectu.org.uk
www.skillset.org

Money

What should I do if I am making money while still studying?

If you begin to sell artwork or creative products or undertake freelance opportunities while you are a full-time student, then you are trading and you should register as self-employed.

Trading legitimately can make you better off financially, with the added bonus that you will not be prosecuted for tax evasion or another legal oversight.

If you take a job during the holidays, then ask your employer to download form P38S from the HM Revenue & Customs (HMRC) website. This allows your employer to pay you without deducting Income Tax, as long as you do not exceed the annual personal tax allowance (PTA) of £7,475 (2011–2012 threshold). Unfortunately, this form cannot be used for part-time work during term time, but you are likely to be below the £7,475 threshold in any case.

If you are trading and have a part-time job at the same time, it can be difficult to understand what you are earning from your business activities. If you are unsure about how to calculate your National Insurance and Income Tax then contact Tax Aid or an accountant for further advice. Remember that when you are self-employed, you only pay Income Tax when your profits have exceeded the personal tax allowance of £7,475 (2011–2012 threshold), and that you can only take your PTA once. You can set your PTA against your business income or job or both. *Please also refer to Q.87 and Q.88.*

RESOURCES

Please also refer to Q.79, Q.84 and Q.88.

www.taxbydesign.com
www.nfea.com
www.hmrc.gov.uk

How do I make money when I leave college?

Whether you have the potential to earn a high income depends on what you have studied and whether you wish to pursue the same activity as a career.

If you have gained qualifications in product, industrial or graphic design, architecture or animation, then there will always be firms offering well-paid employment opportunities.

However, if your work is poetic, or you have graduated from an applied arts programme, it is likely you will only find part-time art-related employment opportunities. Large businesses do not have any permanent roles for visual and applied artists. They may offer a temporary residency, a one-off commission, exhibition space or sponsorship, but not full-time employment. Most fine art and applied arts graduates combine self-employment with some form of part-time job.

If your artwork or creative products have commercial potential, or can be tailored to meet market demand, then the likelihood is you will make more money in the long term.

Many arts graduates often change direction after their studies, and if you are finding it difficult to make a living in your industry sector then this may be the best way for you to proceed.

If your arts degree is a second qualification, then there will be a variety of reasons why you returned to university. You may wish to develop an art practice as an interest, in which case your original career or business activity could be a useful source of revenue if you do not intend to trade after leaving college.

RESOURCES

Please also refer to Q.6, Q.28, Q.74 and Q.79.

Q73

Can I make creativity profitable?

This is a difficult question to answer as many artists and designers do not just create art or design products for money. It could be argued that most creatives never started out with the intention to make oodles of cash.

When businesspeople start a company, they look at the size of the market, how many competitors are in it and then work out if they can make any money. The vast majority of creatives do not think in this way. If creators were only interested in money, then we would not have poetry, experimentation or innovation.

Some industries tend to be better organised in terms of rights management. For example, the music, publishing, photographic and illustration sectors, where wealth can be generated on an ongoing basis through royalty payments and the licensing of rights, have recognised systems in place.

Unfortunately, the rise of the 'free' culture is beginning to destroy previously lucrative deals regarding rights. Equally, many creatives fail to negotiate realistic fees and this has contributed to the erosion of market rates.

There are many reasons why some artists and designers make more money from their practice or business than others. Some may say that studying at esteemed art colleges gave them a head start; others argue that their success is down to specialising in a particular skill.

What is essential is the need to network, and to develop industry knowledge and embrace the subject of business.

RESOURCES

⮕ *Please refer to the resources in Q.1, Q.10, Q.100 and to the Further Reading section at the end of the book.*

What fees should I charge?

There are several ways you can find out how much to charge clients for art and design commissions or as a daily rate.

Start by looking in industry periodicals and visiting the noticeboards and chat room services on their websites. It is also useful to read any research about fees published by professional bodies. Information about salaries and fees can be found on the websites of the following organisations: AN web, Artquest, Creative Review, Design Week, the Association of Illustrators, and the Association of Photographers. Please note that some content is only available to subscribers.

Secondly, talking to friendly industry professionals is a good way to gauge whether you are undercharging.

When taking on commercial commissions you should seek to quote fees under two headings. The first is to secure payment for 'origination' of the art or design work, the second to specify what the work is to be used for. This is termed 'usage'. It is essential to understand licensing in order to clarify the client's use of your work. ⮌ *Please also refer to Q.54.*

However, it is not always possible to separate the two matters and you may have to quote a fee on usage alone, or accept an advance against future sales. If quoting on usage, then you need to understand the industry terms 'above the line' and 'below the line'.

'Above the line' describes the commissioning or buying of artwork, usually for advertising purposes and that appears within a paid or rented space such as advertisements in magazines, hoardings or on television. When agreeing fees for usage, this type of use is charged at a premium rate.

'Below the line' describes the commissioning or buying of artwork for non-rented advertising space. This sort of publicity is in the form of mail shots, packaging, or use on the client's own website, business cards, flyers, posters and signage. When quoting fees for below the line work, you should make it clear in your agreement that the artwork can only be used for the purposes

agreed. If the client desires to reproduce the artwork for other purposes outside the agreement then they will be obliged to negotiate another licence.

You might find that it is more suitable to charge an hourly or daily rate for simple design jobs, residencies, public art projects, design projects, teaching, community work, or leading workshops. These rates can vary widely from £150 to £500 a day.

If you are self-employed, you should avoid working for less than £150 a day where possible. Most freelance designers charge between £240 to £300 a day. For a one-day workshop, the minimum fee should be about £200. The going rate varies around the UK, with some creatives with special skills in and outside London earning more than £300 a day.

RESOURCES

Please also refer to Q.6, Q.24, Q.54, Q.58, Q.59, Q.62, Q.75, Q.76, Q.77 and Q.78.

Industry reports
www.ccskills.org.uk (see 'Blueprints' in the publications section)
www.craftscouncil.org.uk (see 'Making it in the 21st Century')
www.artscouncil.org.uk (various reports)
www.designweek.co.uk (salaries and fees)
www.creativereview.co.uk (various research and online debates)
www.employment-studies.co.uk (Creative Graduates, Creative Futures)
www.artsgroup.org.uk (see the 'Emerging Workers Report')
www.creativeeconomy.org.uk
www.theaoi.com (fees and pricing reports)
www.the-aop.org (fee guides)
www.londonfreelance.org (fee guides)
www.artquest.org.uk (content on fees)
www.a-n.co.uk (various research)
www.skillset.org (various research)

How do I price products?

To get pricing right, with a reasonable profit margin for the artist or maker, can be a complex matter.

Begin by researching how much your competitors are charging for similar artworks, commissions, creative products or services. You should also find out what customers are prepared to pay for similar artworks and products and then work backwards from that point. Instead of trying to make your ideas fit the price, make the price fit the idea.

If you want to succeed in business, you may have to change your mindset about the nature of your fine or applied art form. You must remember that what the market will accept is separate from creativity. You can make the most outstanding artworks and products, but if you cannot sell them at a price customers are willing to pay, your business will not be viable.

Costing a product or service may require the assistance of an experienced adviser who can help you understand the mechanics of the business. It is not simply about working out how much time you have spent at a particular rate and the direct cost (variable costs) of materials. There will be a number of background costs (overheads) to take into account when calculating a trade price, such as utility bills, rent, insurance, equipment costs, marketing, packaging, design or other fees, transport, hire of stands, import or export duty and, possibly, VAT as well.

If you are attempting to get artwork and creative products into galleries and shops then you need to accept that dealers and retailers will mark up your price by 50–300%.

Although you have to deliver the items to the retailer at a 'trade price', it is essential to make some level of profit on that price. If you are unable to do this, and cannot secure representation or stockists, you are limited to selling direct to the public at shows, fairs or online.

The unit cost of manufacturing products can be brought down by outsourcing the work to manufacturers, and can be reduced dramatically by using overseas suppliers.

Artists can find ways to speed up the creation process by being more organised, outsourcing time-consuming tasks such as bookkeeping, and making use of assistants or other professional services to save time.

You can only start to raise your prices once you have established a demand for your artwork, creative products or services.

RESOURCES

Please also refer to the resources in Q.24, Q.54 and Q.74.

www.a-n.co.uk
www.craftscouncil.org.uk
www.artnet.com
www.artmonthly.co.uk (Salerooms)

What are the benefits of negotiation?

Many artists and designers are suspicious of the idea of negotiation. Some see it as a silly game and believe they do not have to bargain with others. This is a very naive view of how business works.

Negotiation is central in obtaining a fairer or better deal for yourself or the organisation you work for. It is an intellectual and creative activity that seems complex at first. But with practice it can help you in all areas of your life, not just in discussions with customers or suppliers.

Negotiation is not simply about securing the fattest fee. It involves matters such as time, resources, intellectual property rights, risk, power and goodwill. If you learn the basic principles, tactics and ideals associated with negotiating a contract, then you will find yourself better off financially and emotionally.

Developing goodwill is an important part of the negotiation process and a vital invisible asset for you and your business. If you do not develop a good rapport with your clients, suppliers or employees, you will not have them for very long. As you build relationships with collectors or customers, you will achieve increased sales and commissions.

RESOURCES

Please also refer to Q.77, Q.78 and the Further Reading section at the end of the book.

Q77

How do I negotiate a deal?

The first thing you must do before negotiating any kind of agreement or commission is to think through the whole project.

Ask yourself a number of questions, including:
1. How much time do I need?

2. What is the lowest/highest fee I will settle for?

3. Is there anything else I can get out of this deal? (This could be studio or storage space, access to high-tech equipment, obtaining high media exposure, gaining a testimonial, retention of copyright and artistic control, or the opportunity to meet new clients.)

4. It is best to write these things down in the form of a mind map® (see Resources). Mind mapping is a good method of helping you to remember your thoughts and make sense of them.

Next, familiarise yourself with the principles of negotiation.
Think through what the other party will want to achieve in the negotiation.

1. What's important to you? What's unimportant?

2. What could be important to the other party and what is not?

3. Think about the best and worst offer you will accept. For example, the best fee, most time, and resources, versus your bottom line, below which you will not go.

Then consider your tactics.

1. Hopefully the other party will be upfront about fees or budgets. If they are vague about these, do not quote a price until you have had time to discuss and fully consider the brief.

2. When quoting fees, go in high. Remember, it is likely that the client will bargain you down.

3. Show a willingness to negotiate and agree to compromises with the client.

4. Stubbornness may win you a fat fee, but if it is at the expense of goodwill, then the working relationship may be a short one.

5. Never reveal to the client what is important or unimportant.

6. Use unimportant matters as bartering chips. Unimportant matters could be time, if at a loose end; transport, if you own a van; or space, if renting a studio.

Finally, do not be rushed into striking a deal – you may be storing up trouble for yourself later on.

RESOURCES

Please also refer to Q.76, Q.78 and the Further Reading section at the end of the book.

www.thinkbuzan.com (Mind Maps®)

When negotiating, what else is there to consider?

When negotiating, it is important to avoid solely focusing on money and intellectual property matters. Try to look at the bigger picture – there could be more to an opportunity than initially appears, if you use your imagination. Always strive for a 'win-win' situation wherever possible. Make sure the atmosphere in meetings remains buoyant and does not deteriorate into awkward stalemates.

Consider your level of enthusiasm when speaking to clients. If you appear too eager for the work, they may think you will do it for free or below the market rate. Open body language and a clear speaking voice will make a good impression. If exuding confidence then clients will view you as a professional and treat you with respect.

To make life less stressful, always negotiate as much time to execute the project as possible. Extra time means the chance to take on other projects.

Always try to offer a licence instead of selling or assigning your rights. If a client insists on owning your copyright, then charge a substantial fee.

Avoid taking all the burden of risk. For example, a royalty-only deal with no fee is fine if the products sell well, but what if they do not?

Saying no to a bad deal demonstrates that you will not be taken advantage of. If you are worth it, the client will come back to you with something more reasonable.

Always try to gain acknowledgement as the author/originator on any reproduction of your artworks or creative products.

RESOURCES

Please also refer to Q.40, Q.41, Q.54, Q.76 and Q.77.

What are the benefits of part-time employment?

After leaving higher education, if you decide to register as self-employed it can be a good idea to find a part-time job. When setting up in business there may not be enough money to live on for the first few months or even years. A part-time job will mean that you have a regular income to cover basic living expenses while income from your self-employment is low.

If you can find art- or design-related part-time or seasonal employment you will learn more about how a creative business or organisation is managed. This experience can be invaluable for your own enterprise. There may be other opportunities that arise from arts-related employment which may also be beneficial to your own arts practice or creative business.

It can be beneficial to spend time in another environment, especially if it is with like-minded people. Many creatives work alone by choice, or because their work is by nature solitary. Some artists and designers can begin to feel isolated, especially if they enjoyed the eclectic social environment of an art college. Having somewhere to go for two or three days during the week, especially if your colleagues like to have lunch together or go to the pub on a Friday evening, can be an energising tonic after time spent in solitude.

Your part-time job doesn't have to be art-related. If you enjoy particular non-arts work, like the people and are paid a reasonable sum, then that is all that matters.

RESOURCES

Please also refer to Q.1, Q.6, Q.71, Q.72, Q.87 and Q.88.

Should I invest in a pension?

It is common knowledge that creative practitioners never retire. However, such an attitude is no guarantee that you would continue to generate the same level of income in later life, especially if you should fall into ill health.

A large number of people do not have any form of pension apart from the state pension provision, which is paid for by National Insurance contributions. To be entitled to a full basic state pension, you need to pay contributions of classes 1, 2, 3, or 4 for 30 years. ➲ *Please also refer to Q.89.*

Retirement age (which at the time of writing is due to be made optional on 1 October 2011) is currently 65 for men and women (but please note the age for qualifying for a state pension is being revised upwards).

From 6 April 2011, the full basic state pension is either £163.44 or £202.40 a week for a married couple (depending on contributions history) and £102.15 for those who are single. There are many other benefits and entitlements for pensioners, including free travel, pension tax credit, housing and council tax benefit.

Private pension schemes always carry some form of risk, as most rely on the Stock Exchange. This means that the value of your pension can fall dramatically, or you could lose it completely if the pension provider becomes insolvent. However, unless you are lucky enough to inherit wealth or property, you do need to think about how you will support yourself in your old age.

RESOURCES

www.direct.gov.uk
www.thepensionservice.gov.uk

Am I entitled to a grant?

You may wish to apply for support while studying, undertaking an experimental project, furthering your research or exhibiting at a trade fair. There are numerous sources of funding from various arts councils, trusts and charitable foundations.

In the UK, applying for grants, loans or sponsorship can take weeks or even months to complete. It is highly likely that the first application for any form of grant funding will be rejected, but it is essential not to be put off; try to gain feedback from the funders and reapply.

Your approach must be focused, and any documents or images included must be to the best professional standard. It is better to be selective and target efforts on two or three applications rather then dozens.

Application forms for grants are effectively mini-business plans in disguise. The organisation wants to know how the money will be spent and what social, artistic or financial benefit it will bring to you or to others. The forms may ask for projected profits or other financial calculations with which you are unfamiliar, and to complete them satisfactorily you may require help from others. Various organisations provide free advice on applying for grants. Short summaries of recent successful applicants' proposals can be found on the arts, film and crafts councils' websites.

RESOURCES

Please also refer to the grant sections of websites listed in Q.1 and Q.49.

Contact your Student Welfare Officer.
www.artquest.org.uk (Funding – Funderfinder access)
www.funderfinder.org.uk
www.thedesigntrust.co.uk
www.ahrc.ac.uk
www.nesta.org.uk
www.j4b.co.uk

How do I apply for a loan?

Before taking out a loan, it is vital to understand why it is required and how much investment is needed. Market research, assessing market demand, calculating costs, predicting cash flow and learning about the legal issues are key elements in underpinning any application for a loan.

Since grants for start-ups are becoming few and far between, applying for a loan can be the only option, especially if you have only a small amount of savings to invest and cannot obtain support from your parents.

If you require a business loan from a bank, then open a business account at your local branch. You may need to write a business plan that demonstrates market demand and financial viability. If you are struggling to write a plan, seek guidance from advisers at local enterprise agencies or innovation centres. Your plan must convince the business bank manager that you can repay any monies loaned with interest.

There are many online loan companies that offer 'no questions asked' loans, but these should be treated with caution. Do not take out a loan without writing some form of plan and gaining professional feedback. If you do not clearly understand the costs involved in setting up a business and how you are going to generate revenue, then taking out a quick loan could lead you into long-term debt problems.

For more information about loans and business planning refer to Q.7 and Q.10.

RESOURCES

Please also refer to Q.7, Q.83 and the resources in Q.1.

www.shell-livewire.org (UK-wide)
www.businesslink.gov.uk
www.gle.co.uk (London only)
www.nfea.com

What is a credit union?

Credit unions are financial co-operatives owned by their members. They are like community banks, offering savings and loan services to local people. Anyone can join a credit union; you will be required to save a regular monthly amount. This can be as little as £10 and can be made by setting up a direct debit or by payroll deduction.

There are credit unions across the UK. Loans are lent to individuals only and can be used for business, home improvements or personal purposes. Some credit unions will only loan you a sum two to three times that of your current savings; others will loan you more depending on their resources. A number of credit unions gain funds from the government to lend to local businesses.

A large number of these co-operatives offer other benefits such as free life insurance on your savings and loans. For example, if you should die, your savings are doubled and given to your next of kin or, in the case of loans, the total of any outstanding balance is paid off.

Credit unions may be willing to take on your credit card debt, so you can then repay the debt at a lower rate of interest.

Savings do not earn interest, but they do attract a dividend. This is based on any surplus achieved by the credit union in the previous year's trading. However, these are only token sums of money and cannot be guaranteed.

RESOURCES

www.abcul.org

What if I have little money coming in?

When setting up as self-employed, whether with or without a part-time job, it can be complicated to understand what you are actually earning. ⮑ *Please refer to Q.87, Q.88 and Q.89.*

If you are struggling to pay bills and rent, it may be time to apply for work-related benefits. At the time of writing it is still possible to apply for Working Tax Credits and Child Tax Credits, and housing and council tax benefits. You can claim these benefits if you are self-employed, are in employment, or are self-employed and in employment.

Applying for Working Tax Credits is straightforward. The benefit is paid via HM Revenue & Customs (HMRC), which has nothing to do your local council or Job Centre. (Please note that at the time of writing tax credits are being reviewed and may, by 2012, be scrapped or merged into another benefit.)

The rules for entitlement are too complicated to sum up in a few lines, but an example would be: a 25-year-old single designer, self-employed, with no children and working in excess of 30 hours a week, with annual net profits of under £13,100. That person would be entitled to Working Tax Credit. If net profits are about £10,000 a year, they would be entitled to payments of £23.88 a week (£1,242 a year). (This is based on 2011–2012 figures.)

Please note that most people living in the UK can claim tax credits. However, there are some exceptions for non-EU residents and restrictions for people with particular types of visas.

You might be surprised to learn that you may claim housing and council tax benefits, though it can be a complex operation. If you provide the housing benefit office with what they ask for, then once your benefit is awarded you will receive it uninterrupted until your circumstances change. This can make a big difference if you are on a low income.

It is important that you do not delay in applying for benefits. If you have not completed your first tax year as self-employed you can still claim, though

you will have to provide evidence of what you have earned to date and possibly some form of cashflow/profit projection. This is why it is important to understand what your profit is. ⟳ *Please refer to Q.87 and Q.88.*

It can be helpful to submit accounts when applying for housing benefit. In the case of self-employed people who have their accounts audited by an accountant, you can submit these instead. Audited accounts are comprised of a few pages that summarise your income and expenses, and state any profit or loss for the year.

Citizen's Advice Bureaux and Job Centres can provide a benefit calculation for you. If you wish to find out what tax credits you could be entitled to, you can check for yourself through the HMRC website or by telephone to the Tax Credits Helpline.

RESOURCES

⟳ *Please also refer to the resources in Q.85.*

www.hmrc.gov.uk (see 'Tax Credits')
www.citizensadvice.org.uk
www.dwp.gov.uk
www.taxaid.org.uk

What if I have no money coming in?

If you are not in work, registered as self-employed, or signing on for Jobseeker's Allowance (full-time students excluded), then HM Revenue & Customs (HMRC) will wonder where you are. It is important not to disappear from the UK tax authorities for too long – firstly, because National Insurance contributions are not being paid and, secondly, because HMRC will wonder how you are supporting yourself.

If you are unemployed, or self-employed and running up an overdraft, apply for Working Tax Credits and housing benefit. If for some reason you have not claimed these benefits, or have done so but simply have no money coming in and cannot find any work, then sign on at the local Job Centre. Then, if you are claiming the benefits, inform the tax credits helpline and housing benefit office that there has been a change in your circumstances.

Many artists and designers gain help from their parents to help keep them going. It is wise to talk to an accountant to clarify the nature of income from benefactors. Is it a gift or a loan? Your accounts will not make sense if this money is not properly recorded in some form.

If in any doubt about your financial affairs you should consult an accountant: they are used to sorting out such problems.

RESURCES

⤴ *Please also refer to Q.80 and Q.89.*

www.moneymadeclear.org.uk
www.bbc.co.uk/moneybox
www.guardian.co.uk/money
www.hmrc.gov.uk (see 'Tax Credits')
www.citizensadvice.org.uk
www.dwp.gov.uk
www.taxaid.org.uk
www.accaglobal.com
www.icaew.com

What happens if I get into debt?

Owing large sums of money to loan companies, banks or credit card companies is now common. However, if you fail to maintain repayments it may lead to court action and visits from bailiffs. The subsequent poor credit rating may prevent you from opening a business account.

If your debts are getting out of hand, do not ignore the problem. Ask for debt advice from the Citizen's Advice Bureau or the National Debt Helpline. Bankruptcy can be avoided by a measure known as an Individual Voluntary Arrangement (IVA). At the time of writing, if you officially owe more than £15,000 of recorded debt (I.O.U.s to friends do not count), a large percentage of money owed to creditors will be written off, leaving you a small percentage to pay over a number of years.

If you are self-employed or a company director, you may still be able to trade after an IVA has been undertaken. It is vital to avoid bankruptcy, since being un-creditworthy will hinder any future business progress.

However, if you own property this can complicate matters and it would be wise to seek further advice from the Citizen's Advice Bureau or National Business Debt Helpline.

For debts of less than £15,000, contact the National Debt Helpline and enquire about a Debt Relief Order (DRO). It's worth bearing in mind that certain debts cannot be included in the IVA or DRO arrangement, such as magistrates' court fines and student loans.

RESOURCES

www.citizensadvice.org.uk
www.nationaldebtline.co.uk
www.nationaldebtline.co.uk/scotland
www.bdl.org.uk/

Q87

So what is profit?

First, you need to understand some basic terms used to describe business expenses. These apply to all forms of business, whether you are self-employed, a partnership, or a company.

These are the four basic bookkeeping terms:

1. Overheads (regular or fixed business costs).

2. Variable costs (costs which vary with the volume of products/services you make/supply).

3. Petty cash (what you have spent in cash on items such as stamps, taxi fares and art supplies).

4. Dual use (tax relief claimed on a percentage of costs that are part-business/part-domestic, such as the use of a car or a flat/house, or a telephone used for both business and domestic purposes).

Gross profit is income minus your direct (or variable) costs only, whereas net profit is income minus all business expenses, i.e. overheads, variable costs, petty cash and dual-use calculations.

The term 'offsetting' means reducing your net profits by subtracting all your overheads, variable costs, petty cash and dual-use expenses from all business income. You offset expenses to reduce the tax liability on your profits. So net profit is what is left after you have deducted all your obvious, and perhaps not so obvious, expenses from your business income. ⮑*Please refer to Q.88.*

It is always worth seeking advice about how to claim the dual-use expenses of running a vehicle, or operating your business from home, or other bills. Simply put, if you run your business from home, you are be able to offset a proportion of the rent/mortgage, council tax and utility bills as a business cost. For most self-employed people, these dual-use calculations can be made at the end of the financial year.

Always remember to keep all your receipts and invoices as evidence of your business expenses. It is worth knowing that many pre-trading expenses can be offset against any profits made in the first year of trading. Usually, the pre-trading period is 18 months before registration. The pre-trading and start-up costs that can be counted include business courses, equipment, computers and vehicles (subject to the capital allowances rules).

RESOURCES

⤳ *Please refer to the resources in Q.71, Q.79, Q.84 and Q.85.*

How is tax calculated?

In the UK, the self-employed have the same tax bands as employees. Everyone in the UK has a personal tax allowance – an amount of money they can earn before any Income Tax is payable.

This Personal Tax Allowance (PTA) can be set against your business earnings or employment if you have a job and/or other income. Remember, you cannot claim your personal tax allowance of £7,475 (2011–2012 threshold) twice. It is worth noting the PTA usually increases slightly every year. *Please refer to Q.87.*

Income tax in the tax year 2011–2012
The tax year runs from the 6 April one year to the 5 April the next, e.g. 6 April 2011 to 5 April 2012.

The first £7,475 of net profit (your PTA) does not attract Income Tax. Above that, the banding is as follows:

On the next £35,000 earned, Income Tax is paid at 20% (this is 20 pence in the pound and is known as Basic Rate).

Over £42,475, Income Tax is paid at 40% (40 pence in the pound and known as Higher Rate).

For taxable income over £150,000, Income Tax is paid at 50% (50 pence in the pound and known as Additional Rate).

Self-employed
If you are self-employed, and have no other job (so do not pay tax through your employer, known as PAYE), then your £7,475 PTA will go through your self-employment. This means that the first £7,475 of your net profits is free from Income Tax.

Self-employed and employed

If you are self-employed and also have a job or several jobs through the tax year then your PTA will go through your employer. This means you will not pay Income Tax on the first £143.75 of PAYE earnings each week (2011–2012 figures).

If your employment only generates a few thousand pounds a year, you can have the remainder of your PTA transferred from your employment to your self-employment. This means you will gain some extra tax relief on your profits from self-employment.

If, however, your part-time job pays beyond the PTA, e.g. £11,000 per year, then it will absorb your PTA This means you will pay basic rate tax (20%) on any money earned over £7,475. So the next £35,000 of taxable income earned through your job and all the net profits from your self-employment will be taxed at 20 pence in the pound.

Limited companies

Tax arrangements and taxation for registered companies are different. Companies pay Corporation Tax on their profits and income tax and National Insurance on directors' salaries.

RESOURCES

To view revised or more recent tax and National Insurance updates, please visit www.taxbydesign.com
www.hmrc.gov.uk
www.a-n.co.uk (Self-employment guides)
www.artquest.org.uk (see the 'Money' section for information on tax and accountancy)
www.taxaid.org.uk
http://appshopper.com/finance/taxcalc (UK Tax Calculator)
www.accaglobal.com
www.icaew.com

Q89

So what is National Insurance?

National Insurance is a system of social insurance that contributes to the welfare state, pensions, schools and the National Health Service (NHS).

Some readers may be disheartened to know that they may be liable not just for Income Tax but National Insurance payments as well. This can be especially frustrating for those who have a reasonably well-paid job and are also self-employed and find themselves not simply paying Income Tax on their job and business earnings, but several classes of National Insurance contributions as well.

You cannot register as self-employed unless you have a National Insurance number. If you plan to live your life and run your business from the UK, then it is advisable to pay National Insurance contributions. If you miss a number of years due to living abroad, you may find you are not eligible for a state pension, access to education, the NHS and other state benefits.

If you have missed paying National Insurance contributions for a number of years it is advisable to seek advice about making up lost contributions.

National Insurance rates

Class 1: paid by employees. The first £139 (2011–2012) of earned income a week is exempt. The money is deducted at source by the employer, at a rate of 12% on the next £139.01 to £817 earned per week. A further 2% is deducted from earnings over £817 a week.

Class 2: paid at £2.50 a week (or £130.00 a year) (2011–2012). It is payable by the self-employed and partnerships, unless you have a Small Earnings Exception. (If predicted profits are likely to be less than £5,315 you will be eligible for an exemption and should complete HM Revenue & Customs (HMRC) form CF10.) If your profits are predicted to be over £5,315, you should set up a direct debit to pay Class 2 contributions, which are payable per calendar month. To do this complete HMRC form CA5601.

Class 3: a voluntary flat rate of £12.60 a week (2011–2012), paid by individuals who are either not working or have income coming from unearned sources such as investments.

Class 4: payable by the self-employed and partnerships if profits are between £7,225 and £42,475 at 9%, and 2% above £42,475 per year (2011–2012). This is paid together with any Income Tax payments due, after a tax return has been submitted to HMRC

RESOURCES

Please also refer to the resources in Q.1.

www.hmrc.gov.uk

Use this website to:

1. Find out how to apply for a National Insurance number if you do not have one;

2. Download a Small Earnings Exception Form CF10;

3. Set up a direct debit from your personal account for Class 2 National Insurance contributions by downloading form CA5601.

4. Register as self-employed by downloading form CWF1. If seeking exemption from paying Class 2 contributions, tick the small box on page 2 of the form.

Q90

What is an invoice?

An invoice is a request for payment. It can be sent by email, usually as a PDF or in the body of the message, or by post. It is often wise, where possible, to hand the invoice to the client when delivering work so that you know they have received it. Some artists and designers require payment up front or on delivery of a painting. Every creative business is different.

Important tips to keep you out of trouble

1. Make sure that hard-copy invoices are printed on letter-headed paper.

2. Avoid using carbon books unless at trade fairs. If you do, retain the copy.

3. Make sure every invoice sent is numbered and dated.

4. Be particularly careful to include the exact name and address of the client and if necessary a delivery address, to avoid any confusion.

5. You can only charge VAT if registered for VAT with HM Revenue & Customs (HMRC). (If you have been charging VAT without being registered, ask an accountant for advice.)

6. Terms and conditions on a final invoice only serve as a reminder and cannot necessarily be enforced.

7. Always print out two copies of an invoice – one copy for your records and the other for the client.

8. There are also pro forma invoices. You can send these to clients if you require money before starting work on a substantial commission. The client may agree to stagger payments, for example, a first payment on presentation of roughs and further payments for work at subsequent stages.

RESOURCES

Please also refer to Q.16, Q.58, Q.91 and the Further Reading section.

How do I get paid?

Always issue terms of trade at the very start of a job and clarify the required credit period in advance with clients (see Q.58). This is the first step to ensuring you will be paid for the sale of artworks and creative products, or the provision of services.

It is generally advisable to make payment terms 30 days from the date of invoice, unless the custom is payment on delivery of goods, in which case the terms are cash on delivery (COD).

You can add the following phrase to your invoice and terms and conditions: 'Payment to be received within 30 days of date of invoice. We reserve the right to charge interest and claim compensation for debt recovery under the late payment legislation if we are not paid according to agreed credit terms.' This will act as a reminder, but is only enforceable if these terms were agreed in advance.

Professional terms and conditions can include a Retention of Title clause so that if you are not paid, you can retain or recover the work you have done.

If, at around 25 days from the date of the invoice, no payment has appeared, it is time to telephone and email your client to check that they received your invoice and approved it for payment. Thanks to telephone and Internet banking, clients can pay a bill in a few seconds and so you should not have to wait for cheques to arrive and then clear into your account.

If the enquiry yields no results, send a reminder by email and by post on day 27. Only after the 30-day period can you start issuing invoices with added interest and penalty fines. If you plan to make administration charges for late payment, then this must be made clear in your terms and conditions and mentioned on your invoice.

For more information on issuing a penalty fine and calculating interest, read the late payment guidelines on the Pay on Time website.

RESOURCES

Please also refer to Q.16, Q.58 and Q.90.

www.payontime.co.uk

What happens if I make a lot of money?

It is possible to enjoy great commercial success as an artist or designer. The question is, how do you prepare for unexpected growth? Any creative can find their income suddenly increases through winning an award or large public commission, gaining a substantial order, lucrative royalty or advertising deal.

It is important to manage your records and accounts competently. If you find within any 12-month period that you are nearing £40,000 of clear profit, then seek advice from an accountant. You may be heading towards the 40% higher tax rate and with Class 2 and 4 National Insurance will end up paying almost 50% in tax. An accountant will be able to advise you on how to cut your tax bill drastically, for example by setting up a limited company.

If you find within any rolling 12-month period that your total income, not profit, is nearing £70,000, then it is advisable to seek advice from an accountant about whether you should register for Valued Added Tax (VAT) with HM Revenue & Customs (HMRC). When your income hits £70,000 in any 12-month period (2010-2011 threshold) it is compulsory for you to register.

If you are making large profits then it could be wise to speak to a financial adviser about how to make the most of your money. You might like to pay off your mortgage or set up a pension. Equally, you may wish to reinvest any surplus in your own business, such as buying a studio or retail outlet, purchasing new equipment, or taking on staff.

If taking risks with stocks and shares is not for you, then finding a good savings account could be a sensible move as it will be better then having a large sum of money languishing in a business account. You might suffer a bad patch in the future and being able to draw funds from a savings account could be a sensible use of excess profits.

RESOURCES

⮑ *Please also refer to Q.93.*

www.hmrc.gov.uk
www.fsa.gov.uk
www.aifa.net
www.guardian.co.uk/money
www.bbc.co.uk/moneybox
www.accaglobal.com
www.icaew.com

When should I register for VAT?

Value Added Tax (VAT) is a transaction tax that is charged on most products and services. The standard rate of UK VAT is currently 20% (2011–2012). There are also reduced rates and zero rates that apply to a limited number of goods and services.

Businesses can only charge VAT if VAT-registered with HMRC They will usually be required to complete a VAT return every three months.

At the time of writing, only businesses whose turnover is greater than £70,000 (2010–2011 threshold) in any 12-month period are required by law to register for VAT and add VAT to their prices.

Any business whose turnover is below £70,000 has the choice of either registering for VAT voluntarily or not.

It may be advisable for UK businesses to register for VAT if trading with other VAT-registered businesses within the European Community, such as large stores, firms or galleries. The general rule is that if all your customers are VAT-registered businesses themselves (e.g. if you are a freelance designer working for a range of companies), then you will be better off financially if you register for VAT voluntarily. However, if your income is low, you may prefer not to register for VAT to keep your financial affairs simple.

At the time of writing, if all your customers are members of the public (e.g. you are selling your own products from market stalls), then you will be better off financially it you can avoid registering for VAT until your turnover exceeds £70,000 in any 12-month period.

RESOURCES

⊃ *Please also refer to Q.88 and Q.92.*

Why must I keep records?

It is a legal requirement to keep proper records when trading. Proper records are not boxes of muddled receipts accompanied by ad hoc bank statements.

Records must be kept for six years. So, if you start trading in 2011–2012 you should retain your records until January 2018. It will help you if you store them in labelled A4 files or archive boxes, with all receipts and bills bagged by month in transparent plastic sleeves.

You should keep evidence of all expenditure and sales, such as invoices and copies of customer's receipts, and all supporting documents relating to business transactions, including business and personal current account bank statements, deeds, contracts, insurance records, important email correspondence and receipts.

All creative businesses should keep stock and work-in-progress records, and details of money introduced into the business from savings, grants, loans from relatives or banks. Also note any money taken from the business for personal use, usually referred to as 'drawings' for artists and designers who are sole traders.

Keep a full set of accounts in Microsoft Excel spreadsheets, if possible, or manual records if not, of all payments coming in and payments going out. You may require two to four spreadsheets for each month. Remember to keep back-up copies of any digital spreadsheets, ideally stored in a different location from the main copy.

Finally, keep documents relating to any indirect/dual-use expenses including, receipts for fuel/petrol, domestic rent, domestic mortgage, council tax and utility bills such as electricity and gas.

RESOURCES

www.taxbydesign.com (For free pre-formatted Excel spreadsheets)
www.hmrc.gov.uk

Q95

What happens if I do not keep my records properly?

If you fail to maintain proper records, then it is likely that you will not be entering the correct amount of profit or loss into your tax return, which is also referred to as 'Self-Assessment'. If you do not put money aside to pay your tax later in the year, then when the tax bills arrive you might find you do not have enough money to pay them.

HM Revenue & Customs (HMRC) investigate businesses if their tax return entries appear suspicious in some way. HMRC officers could, in theory, turn up on your doorstep unannounced and ask to see your records. If your records are missing or are not complete then you may be taken to court, which could lead to a fine or, for very serious cases such as fraud, imprisonment.

➲ *Please refer Q.94* for more details about what to retain as business records. If you are worried that your current or previous years' records have not been compiled properly, for example you have not included spreadsheets of income and expenditure, then contact an accountant for further advice.

RESOURCES

www.artquest.org.uk (see 'Accountants')
www.taxaid.org.uk
www.accaglobal.com
www.icaew.com

Last thoughts

Q96

Should I make a will?

If you are starting to sell artwork and design pieces, or have a number of public and commercial commissions, then it is wise to have a will drawn up. Copyright, resale rights, and other rights such as trademarks will still be commercially exploitable after your death.

You can leave your rights and the original artworks or designs to your company, family, friends or a charity. As owners of the rights, they will be able to benefit from income generated by the licensing and resale of your artworks.

Often, only the artist, their representatives, and accountant will have inventories of the artist's commissions, sales, and where original works are stored. When creators die without a valid will drawn up by a specialist solicitor, there can be a great deal of unnecessary confusion over their estate. To draw up a comprehensive will, involving different intellectual, licensing and resale rights, will require the services of a good wills and probate solicitor with experience in dealing with the cultural sector. Such a solicitor will be able to ensure the appropriate provisions are incorporated.

If you fail to make your wishes clear in a will before you die it can lead to property disputes, bequests not being honoured and artwork, or important documents, being lost or destroyed.

RESEARCH

Please also refer to Q.52, Q.53, Q.54, Q.55, Q.56, Q.57 and Q.64.

www.step.org

How do I find out about future opportunities?

Developing extensive networks in your community, industry or field of research is a key route to creating potential business opportunities. If you are not seeking a life in secure employment then, as mentioned previously, you have to make your own luck and generate opportunities for yourself.

There are a number of ways to meet people like yourself who are trying to carve their own path in life, such as joining professional bodies, reading art and design periodicals, and going to conferences, private views, press launches and parties. Unlike being in a job, there will be no one telling you what to do, so it is really down to you to use your initiative to discover agents, dealers, commissioners, buyers, clients, customers or collectors.

You cannot ignore London, or any other major city around the world, in your quest to fulfil your ambition. These are the places where you will find the majority of artists, designers, agents, dealers, galleries, top stores, advertising agencies, film production companies and art colleges.

Remember, it is wise not to undertake too many projects at once. Your energies could be spread too thinly through a lack of focus. Be selective about opportunities you decide to pursue, and it is likely that you will make progress.

RESOURCES

Please also refer to Q.1, Q.10, Q.13, Q.44, Q.45, Q.74 and to the Further Reading section at the end of the book.

What happens if things go wrong?

Whether setting up a business, or working as an employee, there are many problems that may easily knock you off course.

In the UK, tens of thousands of art and design students graduate every year. They are joined by many others from overseas who come here to look for work. This stiff competition means that it is becoming increasingly difficult, especially in London and the South East, to earn a decent level of income within the visual arts.

Many creatives make the common error of not learning enough about business, marketing, legal and financial matters. As mentioned in earlier questions, being successful in business is a skill distinct from being an artist or designer.

Often you will not know immediately that something has gone wrong, but you can minimise the likelihood of failure by researching the marketplace and knowing thoroughly how it works. Only then will you be able to make more informed decisions about your business and thus avoid costly mistakes.

If you find yourself in any kind of legal or financial trouble, speak to a solicitor, business adviser, accountant or debt adviser. They have the experience and knowledge to help you to find the best solution.

Work with honest people. If you are self-employed, or in business with others, write a business plan. Agreeing joint goals and gaining feedback on your ideas from advisers can be invaluable and help you to avoid making mistakes.

RESOURCES

⊃ *Please refer to the Further Reading section at the end of the book.*

Can I cope with rejection?

Rejection is part and parcel of being in business. Failure is not a condition unique to the visual arts sector – talk to anyone in business and they will tell you about being rejected and may offer their own advice about how to cope with any disappointment.

Whatever venture you embark on, whether you are trying to secure representation or entering a competition, there is always the possibility that your first attempt will not succeed. It is vital not to let any kind of knock-back destroy your confidence or, worse still, make you depressed.

If, or when, you face the dreaded 'no' or 'we will retain your details on file' phrase, ask for feedback on your submission from the business or organisation concerned. Sometimes people will be kind enough to offer some constructive criticism if you telephone or email them.

When doing something new, you should view being ignored or dismissed as simply part of the process of eventually being accepted for the opportunity you are seeking. Persistence pays off.

Sometimes, it may be too difficult to earn a decent or regular income from the art or design discipline you studied. However, you will find another role for yourself within the visual arts or creative industries if you seek it. Take the example of Chad Hurley, who originally studied graphic design before making his fortune from an experimental web-video venture called ... YouTube.

RESOURCES

Please refer to the Further Reading section at the end of the book.

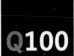

Q100

What can I do to make my creative venture a success?

To be successful in the art and design sectors, you must embrace the subject of enterprise. Being able to generate 'lucky breaks' is an essential skill if you wish to attract opportunity.

Where the visual arts are concerned, studying at one of the country's top art colleges can be an advantage. If this is not possible then living, studying in or visiting London, or other major art centres, for short periods is of great benefit. *Please also refer to Q.21.*

Joining professional bodies, online art networks or private art clubs are useful routes to meeting your contemporaries and discovering opportunities; developing industry contacts is essential.

Avoid becoming actively engaged in the 'free' culture. All that is achieved by giving your artworks or creative products away will be the collapse of your own industry. Being able to invest sufficient money in your enterprise is vital, as without adequate funding your venture will fail.

As mentioned in several answers to questions in this book, learning about business and legal issues, such as intellectual property, is essential. You need to understand any legal details so that you can protect and fully exploit (make use of) your intellectual rights.

Keep your mind and body in good shape. Without your health you cannot run any business properly.

Finally, learn the art of alchemy – not actually turning base metals into gold, but finding ways to transform your knowledge, ideas and skills into personal wealth.

That's all for now...

I hope this business pocket book has helped to clarify some of the basics and encourages you to develop an enquiring mind, the resource of all successful people.

Do you have Q.101?

If so, please send it to *alison@alisonbranagan.com*

Further reading

Abbing, Hans, *Why Are Artists Poor? The Exceptional Economy of the Arts*
(Amsterdam: Amsterdam University Press, 2002).

Austen, Pam and Bob, *Getting Free Publicity*
(Oxford: How To Books, 2004).

Borkowski, Mark, *Improperganda: The Art of the Publicity Stunt*
(London: Vision On, 2000).

Branagan, Alison, *Making Sense of Business: A no-nonsense guide to business skills for managers and entrepreneurs*
(1st edn, London: Kogan Page, 2009).

Branagan, Alison, *The Essential Guide to Business for Artists and Designers*
(London: A&C Black, 2011).

Burke, Sandra, *Fashion Entrepreneur: Starting Your Own Fashion Business*
(1st edn, Oxford: Burke Publishing, 2008).

Buzan, Tony and Buzan, Barry, *The Mind Map® Book*
(2nd edn, Essex: BBC Active, 2006).

Carnegie, Dale, *How to Win Friends and Influence People*
(2nd edn, London: Vermilion, 1998).

Chappell, David and Willis, Andrew, *The Architect in Practice*
(9th edn, Oxford: Blackwell Publishing, 2005).

Davies, Gillian, *Copyright Law for Artists, Photographers and Designers*
(London: A&C Black, 2011).

Dyson, James, *Against the Odds: An Autobiography*
(New York: Texere, 2002).

Goltz, Jay, *The Street-Smart Entrepreneur*
(Omaha, Nebraska: Addicus Books, 1998).

Goworek, Helen, *Careers in Fashion and Textiles*
(Oxford: Blackwell Publishing, 2006).

Hart, Tina, Fazzani, Linda and Clark, Simon, *Intellectual Property Law*
(4th edn, Hampshire: Palgrave Macmillan, 2006).

Hedges, Roy and Walkley, Roger, *Bookkeeping Made Easy*
(3rd edn, London: Lawpack Publishing, 2006).

Herbert, Jo (ed.), *Writers' & Artists' Yearbook 2010*
(103rd edn, London: A&C Black, 2009).

King, Stephen, Macklin, Jeff and West, Chris, *Finance on a Beermat*
(2nd edn, London: Random House, 2008).

MacDonald, Kyle, *One Red Paperclip: The story of how one man changed his life one swap at a time*
(2nd edn, London: Ebury Press, 2008).

Manser, Sally and Wilmot, Hannah, *Artists in Residence: A handbook for teachers and artists*
(2nd edn, London: St Katherine and Shadwell Trust, 2007).

Miller, Harley and Miller, Cally, *A Proper Living From Your Art: How to make your painting pay*
(1st edn, Findhorn Bay, Moray: Posthouse Printing and Publishing, 2000).
(Revised free edition available on download from www.harleymiller.com.)

Mornement, Caroline, *Second Steps*
(4th edn, Yeovil, Somerset: BCF Books, 2006).

Moses, Rachel, *Business Start-up Guide for Designers and Makers 2008*
(4th edn, London: Design Nation, 2008).

Olisa, Elinor, *The Artists' Yearbook 2010/11*
(London: Thames and Hudson, 2009).

Portas, Mary, *How to Shop with Mary Queen of Shops*
(1st edn, London: BBC Books, 2007).

Ruston, Annabelle, *Starting Up a Gallery and Frame Shop*
(London: Fine Art Trade Guild and A&C Black, 2007).

Ruston, Annabelle, *The Artist's Guide to Selling Work*
(London: Fine Art Trade Guild and A&C Black, 2005).

Shaughnessy, Adrian, *Graphic Design: A user's manual*
(1st edn, London: Laurence King Publishing, 2009).

Smithson, Pete, *Installing Exhibitions: A practical guide*
(London: A&C Black, 2009).

Stern, Simon, *The Illustrator's Guide to Law and Business Practice*
(1st edn, London: Association of Illustrators, 2008).

Thomas, Gwen and Ibbotson, Janet, *Beyond the Lens*
(3rd edn, London: Association of Photographers, 2003).

Wedd, Kit, Peltz, Lucy and Ross, Cathy, *Artists' London: Holbein to Hirst*
(1st edn, London: Merrell Publishers, 2001).

Williams, Sarah, *The Financial Times Guide to Business Start-up*
(Harlow: Prentice Hall, 2010).

Essential Guides
from A&C Black

essential guides

The Essential Guide to
**Business for
Artists & Designers**

With a foreword by Sir James Dyson

ALISON BRANAGAN

'This book cuts through the clutter and the jargon of business, giving clear, simple advice about how to make a success out of your art practice or creative company.'
Sir James Dyson

Features:

- A foreword by Sir James Dyson
- Profiles of established artists & designers
- Illustrated mind maps
- Overview of business start-up and legal matters
- Records, tax and basic bookkeeping
- Money management
- Self promotion